THE VICTORIA & ALBERT MUSEUM'S TEXTILE COLLECTION

BRITISH TEXTILE DESIGN FROM 1940 TO THE PRESENT

THE VICTORIA & ALBERT MUSEUM'S TEXTILE COLLECTION

BRITISH TEXTILE DESIGN FROM 1940 TO THE PRESENT

Ngozi Ikoku

V&A Publications

In memory of Daniel McGrath, talented photographer and inspiring individual (1964–96).

First published by V&A Publications, 1999

V&A Publications
160 Brompton Road
London SW3 1HW

ISBN 1851771255

A catalogue record for this book is available from
the British Library

Photography by Ian Thomas and Daniel McGrath
Designed by Area

Printed in Singapore by Imago

FRONT AND BACK COVER: Detail of rag rug designed and woven by John Hinchcliffe
in 1978. T 161-1978

CONTENTS

6 ACKNOWLEDGEMENTS

I wish to thank sincerely present and past members of the V&A Textiles & Dress Department and the Photographic Studio, especially Valerie Mendes, Linda Parry, Debbie Sinfield, Lisa Hirst, Susan Powell-Worpell, Ian Thomas and the late Daniel McGrath, whose combined expertise and experience helped to bring this publication to fruition. Thanks are also extended to colleagues in other departments, including Elizabeth Salmon of the V&A Archive of Art and Design, Jo Wallace in the Picture Library, Charles Newton and Ruth Walton from the Prints, Drawings and Paintings Section, Mary Butler and Miranda Harrison of V&A Publications, and my editor Colin Grant.

I would like to express my thanks to all those outside the Museum who provided information to help complete this book – particularly Sue Kerry of Warner Fabrics, Freddie Launert of Sandersons, John Sheldon of Cavendish Textiles, Adam Mansell of the British Fashion Council, Brenda Brinkley at the Tate Gallery Archive and Josephine Ross. I am also enormously grateful to Colin Croft for his support.

Above all, we are indebted to the designers, makers, manufacturers and donors without whose creative genius, foresight and generosity this publication would not have been possible.

FOREWORD

In tracing the fascinating evolution of British textile design from 1940 to the present, this book brings up to date the series of V&A monographs on the world's greatest collection of British fabrics. The lucid text and revealing photographs show the outstanding talents and versatility of the nation's fabric designers and craftspeople as well as the skill and acumen of its manufacturers and the vitality of its trade associations. This is set against the harsh economic reality of recent industrial decline and the struggle for survival in the face of global competition. The significance of the interplay between the fine and the applied arts is also highlighted. Only a collection as varied, extensive and pristine as the V&A's permits such an exciting visual promenade through fifty years of pattern, colour and creativity.

In the 1940s V&A curators, with admirable tenacity, maintained the Museum practice of collecting fabrics from current production that were considered to be in the stylistic vanguard. During and just after the war curators were undeterred by conscription, austerity and cultural uncertainty and secured an excellent collection of Utility and other furnishing fabrics manufactured during a time of government restrictions and rationing. The relaxation and gradual revival that peace brought is reflected in a significant increase in the number of acquisitions. They show that it took some years for the dyestuffs' industry to regenerate itself and for designers to cast off the drab browns, beiges and muddy oranges that prevailed during the mid-1940s. The V&A joined the forefront of recovery by turning its entire ground floor over to the 1946 *Britain Can Make It* exhibition, which marked a stylistic turning point in the applied arts.

By the early 1950s the UK was an international force producing award-winning textiles with the so-called Contemporary designs. Lucienne Day's *Calyx* of 1951 made a huge impact and subsequently became a leitmotif for the 1950s. Samples in the collection capture the popular taste of the decade and feature designs with a plethora of spindly lines punctuated by nodules in the favourite colours of acid yellow, greeny-grey and orange with black. Fortunately, the curious Festival of Britain experiment undertaken by the Festival Pattern Group is well represented – the molecular structure of blood was even used as a starting point for designs. The V&A forged a fruitful link with the Design Council to acquire textiles which had received their design awards. The innovative *Ambassador* magazine captured the healthy state of British textiles throughout the 1950s. The publication particularly endorsed artist–manufacturer liaisons, such as relationships so successfully fostered by Edinburgh Weavers, David Whitehead, Heal's and, at the beginning of the 1960s, Hull Traders.

In the swinging sixties a new generation of lively designers destined to invigorate textile design emerged from British art schools. The new wave fabrics were closely allied to movements in painting and sculpture and in many ways represent a high point in British textile design. Assertive and powerful, these fabrics appealed especially to the young. So strong and colourful were Hull Traders' screen prints of the late 1960s that Manchester University made them into pictures to brighten their corridors by stretching lengths of the fabric over large square frames. Floral repeats, stripes, checks and plains continued as the industry's mainstay 'bread and butter' lines, while the trend for retrospective interiors was fed by the revival of Art Nouveau patterns led by Liberty's. Designers Eddie Squires and Sue Palmer (for Warners) produced novel figurative designs such as the commemorative *Space Walk* of 1969.

Reflecting the growing importance of craft textiles since the early 1960s, the V&A has acquired pieces by most leading practitioners which represent the multiplicity of craft techniques as well as the inventiveness of British designer-makers.

From the 1960s to the 1980s a series of V&A textile exhibitions explored aspects of the twentieth-century collection and additionally surveyed the contribution of British firms including Warners, Morton and Sundour, Liberty's, G. P. and J. Baker and Ascher. As a result of these initiatives the collection grew, with pieces from the mid-1970s illustrating the downturn precipitated by the 1973 oil crisis. Designers resorted to small-scale geometric prints, often in a safe and versatile beige, and to diminutive all-over 'cottagey' florals which indicated a yearning for the rural idyll. For a short while a period of indecision brought a halt to stylistic invention and few modern textiles were obtained by the Museum, but by the early 1980s confidence had returned and collections such as Collier Campbell's dynamic and vividly coloured '6 Views' were acquired. To record the extension of this creative boom in the mid-1980s to 1990s, the Museum secured work by Timney Fowler, English Eccentrics and Neil Bottle.

The splendid photographs in this book can now provide instant visual access to a major part of the V&A's unique collection. The selection also conveys the rich diversity of the collection and presents a chronological overview of the vicissitudes of style and shifts in taste of the post-war period.

Valerie D. Mendes
Chief Curator, Department of Textiles and Dress

British Textile Design

from 1940 to the present

Ngozi Ikoku

This volume gives a brief introduction to a major part of the V&A Museum's collection of British textiles dating from 1940 to the present, and its colour plates highlight some of the most significant stylistic changes that have occurred during this period. For practical reasons, due to the considerable size and scope of the collection, this survey features woven, printed, painted and dyed textiles and excludes carpets and embroideries.

WARTIME AUSTERITY

Despite severe cutbacks in supplies and production during the Second World War, the concept of 'good' design, which had arisen in the nineteenth century, continued to be of importance and was supported by the Utility Scheme introduced by the British government in 1941. The system was devised to ensure that the civilian population continued to have some access to consumer goods. Responsibility for the creative development of these products was placed in the hands of a number of chief practitioners of the day, including Enid Marx who represented the field of textile design. Her brief, as textile consultant/designer on the Design Panel of the Utility Furniture Advisory Committee (established mid-1943), was to design uncomplicated patterns that could be produced within the technical and cost restrictions imposed by wartime austerity. The textiles that she developed were generally of a geometric or abstract nature with small-scale repeating patterns. Samples, such as *Spot and Stripe* (plate 8), *Honeycomb* (plate 7), *Ring* (plate 6) and *Chevron* (plate 9), were initially

trialled by their manufacturer Morton Sundour Fabrics and, on approval from the Board of Trade Design Panel, were released to the trade generally. Some designs were executed in a dark brown which was subsequently eradicated from the final restricted and undeniably dull palette of rust, green, blue and natural. Enid Marx was critical of the eventual choice of colours and in correspondence with the Museum commented: 'I certainly would have condemned the "rust" which I think most deplorable and responsible for much of today's low standards of public taste'.[1]

In spite of Marx's severe dislike of rust, the woven Utility patterns (plates 6, 7) were influential, and their impact can be traced in a series of printed rayon dress fabrics designed by Eric Stapler in 1945 for Ascher and marketed as 'linen tweeds' (plates 11, 12). Defined as 'Non-Geometric' at the time,[2] these designs bear a close resemblance to Utility patterns in terms of design, scale and limited use of colour. The painterly nature of these printed dress fabrics, described as 'a deviation of the usual geometrically exact design',[3] is echoed in *Totley* (plate 10), which was designed in 1947 by Marianne Straub while head designer for Helios, a company noted for producing inexpensive ranges of stylish furnishing fabrics.

Textiles with patriotic messages also became current during the Second World War. They were produced by a number of enterprising manufacturers including member firms of the Calico Printers' Association and Jacqmar, a company committed to improving standards in British textile design. Issued primarily as dress fabrics and accessories printed onto rayon – a wartime substitute for silk – these novelty designs

proved popular and illustrated aspects of the wartime story of Britain. *Coupons* (plate 3) was inspired by clothes-rationing introduced in June 1941, while the border of *Victory V* (plate 1) contains the Morse code for 'victory'. The figurative *Careless Talk Costs Lives* handkerchief (plate 2) was derived from a series of posters created by Fougasse (the pseudonym of Cyril Kenneth Bird, 1887–1965) and published by the Ministry of Information in February 1940, and *London Wall* (plate 4) depicts bill stickers bearing patriotic slogans and wartime propaganda. Reflecting the sense of national unity during the Second World War, these fashionable textiles also acted as morale boosters and added notes of colour to the wartime wardrobe.

THE RETURN TO PEACE TIME:
NEW DESIGN SOURCES

The Festival of Britain held in 1951 provided further opportunities for textile design and manufacture. Two very distinct types of pattern emerged at this event: one was inspired by scientific, crystal-structure diagrams drawn to record arrangements of atoms in such substances as haemoglobin, insulin and chalk (see plates 23–31); the other was based on the abstract forms and organic shapes of the so-called 'Contemporary' style which manifested itself in industrial design and the decorative arts (see plates 32–44).

Mark Hartland Thomas, chief industrial officer at the Council of Industrial Design, was largely responsible for the development of the textile designs derived from crystal-structure diagrams. When setting up the Festival Pattern Group in 1949, he stated that 'we are at a stage in the history of industrial design when both public and leading designers have a feeling for richness in style and decoration, but are somewhat at a loss for inspiration'.[4] The idea for this project was perfect for the scientific theme of the Festival, which had been planned as a 'combined exhibition of science, technology and industrial design'.[5] It was brought to Hartland Thomas's attention by Professor Kathleen Lonsdale, who gave a paper on crystallography at a weekend course in Ashridge organized by the Society of Industrial Artists in May 1949. Her colleague, Dr Helen Megaw of Girton College, Cambridge, acted as the Festival Pattern Group's scientific consultant, and supplied the diagrams for interpretation by designers and manufacturers. The crystal patterns were deemed particularly appropriate for use in textile design because of their repetitive symmetry and natural beauty. It is important to note, as Mark Hartland Thomas pointed out, that crystallography 'was not providing a ready-made short cut to good design'[6] but that it acted as an inspirational springboard for designers. This is clearly illustrated by comparing *Surrey* (plate 31), one of the most successful designs of the Festival Pattern Group, with *Afwillite* (plate 30). Both have their origins in the analytical diagram for Afwillite but have totally different scales and decorative appeal.

Despite the Council of Industrial Design's attempts to lay the foundations of a new design aesthetic, the influence of the crystal patterns was short-lived. The legacy of the Festival Pattern Group, however, was the idea of recruiting twenty-six leading British manufacturers, including British Celanese, Warner & Sons, Barlow & Jones, Vanners & Fennel and the Old Bleach Linen Company, to promote 'good' design.

The Contemporary textiles featured at the Festival of Britain were to have a profound effect upon textile design throughout the 1950s. Produced predominately as furnishing fabrics and printed in bright lively colours onto rayon, linen and cotton, the designs represented an alternative to the crystal patterns and offered welcome relief from the drab colours of the war years. The style was epitomized by the highly original, award-winning textile, *Calyx* (plate 40), by Lucienne Day. Although it was initially considered too 'way out' by Heal's, Lucienne Day eventually persuaded them to print the design;[7] it went on to break all sales records for the period and was immediately copied by an enterprising New York manufacturer.

Calyx came to represent all that was new in 1950s textile design. The Contemporary style was largely inspired by abstract art, especially the work of Paul Klee (1879–1940), Joan Miró (1893–1983) and Alexander Calder (1898–1976), and also explored geometric shapes in the form of grid patterns and scientific images such as spindles, nodules and crystals. Favourite colours were stringent yellows and reds, often combined with a sludgy grey-green known as 'elephant grey'. A major exhibitor at the Festival of Britain supplying

innovative fabrics in the Contemporary manner was the enterprising firm David Whitehead (plates 32–5, 37, 39), who displayed twenty examples produced by young designers such as Terence Conran, Marian Mahler and Jacqueline Groag. The lasting success of the Contemporary-style textiles after this national event was due largely to the talent of the young designers and the foresight of the manufacturers such as Heal's and David Whitehead who were prepared to take financial risks with design. John Murray's work as director of David Whitehead from 1948 to 1952 played an important role in the democratization of the 'designer look'. Convinced that good design was vital for commercial success and that 'the cheap need not mean the cheap-and-nasty', he believed that the way forward was to 'put someone with professional design training in a position to say what shall be produced'.[8] By the late 1950s, although traditional textile design still formed a pivotal part of the market, modern designs were accepted for use in many different types of interior, ranging from domestic settings to municipal spaces.

ARTIST-DESIGNED TEXTILES

In 1941 the enlightened Alistair Morton, director and styling manager of Morton Sundour Fabrics and a designer in his own right, wrote an article entitled 'The Birth of a Furnishing Fabric', which highlighted the need to establish 'fuller co-operation between British artists and manufacturers'.[9] Catering for those with a taste for the avant-garde, Zika Ascher for Aschers and Alistair Morton for Edinburgh Weavers (the experimental branch of Morton Sundour Fabrics) led the practice of commissioning textile designs from artists. This enterprise of linking artists with the textile industry was not only successful in raising standards in British textile design but also boosted the production of high quality goods for the home and export markets in the post-war period.

Frustrated by wartime conditions and the general drabness of the textiles during this period, Zika Ascher began in 1944 to contract some of the most renowned artists of the day to create designs for translation onto cloth. Best celebrated for the head squares designed by artists such as Graham Sutherland, Ben Nicholson, Julian Trevelyan, John Piper, Barbara Hepworth and Henri Matisse, Zika Ascher also produced innovative artist-designed yardage for both dress and furnishing fabrics. The flexibility offered by the screen-printing process, which does not restrict the size or nature of a design too heavily, enabled artists' work to be sensitively interpreted. These qualities are exemplified by dress fabrics such as Feliks Topolski's free-flowing *Jungle* (plate 19) and the textile designed by Henry Moore (plate 17) based on his figurative drawings, both of which clearly maintain the highly distinctive style of these pre-eminent artists. Whereas the Ascher scarves and panels were essentially a straightforward translation of the artist's work, patterns in repeat required Ascher's intervention and subtle interpretation in both the colour and organization of the design. These small-scale designs printed primarily on rayon were used by leading ready-to-wear dress companies and fashion designers of the day including Spectator Sports, Rima, Matita and Mattli.

While director of Edinburgh Weavers from the late 1950s until his death in 1963, Alistair Morton continued a practice he had launched before the war and commissioned many artists, including Cecil Collins (plate 56), Humphrey Spender (plate 60), Keith Vaughan (plate 57) Victor Vasarely (plates 68, 75), Alan Reynolds (plates 52, 74), Marino Marini (plates 58, 59), William Scott (plate 73) and Elizabeth Frink (plate 55), to create designs which could be adapted for woven and printed textiles. The innovative nature of these textiles was immediately acknowledged as they won awards from the Council of Industrial Design. *Adam* (plate 57), for example , a 1958 award winner, was described by the Council of Industrial Design as being 'the sort of bold experiment that is entirely in the hands of artists and craftsmen of the highest calibre, backed by the enthusiastic conviction of a company noted for its consistently progressive design policy'.[10]

In a similar vein, but for a wider, less exclusive market, the manufacturer David Whitehead from the 1950s (under the design direction of Tom Mellor) was also responsible for producing commercially successful artist-designed textiles. The movement uniting fine art and industry was further encouraged by the forward-looking exhibition 'Painting Into Textiles' (sponsored by the British export magazine, *The Ambassador*) held in 1953 at the Institute of Contemporary Art London. The declared intention was to bring 'the artist and converter into closer communication' in the hope that 'trade will be enriched, kept fresh and alive'.[11]

GEOMETRY AND ABSTRACTION

From the early 1960s until the oil crisis of 1973 the general trend in progressive textile design was for large-scale abstract and geometric patterns produced for both contract and domestic markets. Such designs, clearly influenced by the prevailing trends in sculpture and painting, were particularly fashionable from the early to middle years of the decade. They were produced by the versatile screen-printing process which enabled manufacturers to issue avant-garde design at relatively low costs.

One of the most significant designers of the period working in the abstract mode was Shirley Craven, a graduate of the Royal College of Art who in 1963 became a director of the Hull Traders company which had a 'high reputation for producing adventurous and exciting designs'.[12] Under her design direction and as a result of the close working relationship she had with the managing director of the company, Peter Neubert, Hull Traders became a serious leader in the field of innovatory textile design, commissioning work by top designers and artists such as Peter McCulloch, Doreen Dyall, Dorothy Carr, Althea McNish, Humphrey Spender, John Drummond and Eduardo Paolozzi. Craven's dramatic and highly original designs including *Division* (plate 62) and *Shape* (plate 64) in 1964 won a number of Council of Industrial Design Awards.

The fine art movement known as Op Art exerted a powerful influence on textile design. With its largely black and white geometric directional forms creating often unsettling optical illusions, the movement reached its peak of popularity around 1965. This style first manifested itself in textile design in the early 1960s with the notable collaboration between Victor Vasarely, one of the pioneers of Op Art, and Alistair Morton of Edinburgh Weavers, who had an ability to discern future trends and emerging talents in the realm of textile design (plates 68, 75). Op Art-inspired textiles, although they did not have a widespread general appeal because of their visually disturbing avant-garde nature, were admired by the design establishment for their striking quality and novelty value. *Impact* (plate 71), designed by Evelyn Brooks for Heal Fabrics and promoted as a 'fabric

of unblinking splendour',[13] won the *House and Garden* Award in association with the Cotton Board in 1965. The equally impressive textile *Spiral* (plate 72), by the designer Barbara Brown, received a Council of Industrial Design Award in 1970. During the second half of the decade this style gave way to an arguably less potent polychromatic appearance demonstrated by *Complex* (plate 90), *Extension* (plate 92) and *Metropolis* (plate 91).

THE INFLUENCE OF POP ART

Pop Art, with its essential qualities of accessibility, wit and liveliness combined with graphic imagery, had a profound impact upon the appearance of printed dress and furnishing fabrics from the late 1960s to early 1970s. This phenomenon was recorded in the V&A exhibition *The Fabric of Pop* (1974). Andy Warhol's famous soup can images (plate 101) and portraits of Marilyn Monroe (plate 103) were readily mimicked on printed yardage, and textiles such as Zandra Rhodes's amusing 1968 design *Lipstick* (plate 99) also maintained the pop spirit. Influenced by Guy Bourdin's advertisement for Christian Dior Cosmetics, the design is indicative of Rhodes's appreciation of commercial imagery; as she explained, 'I love the strength of good imaginative advertising'.[14] Produced by a new generation of designers including John and Molly Dove, Jane Weallens (plates 98, 100, 104), Christopher Snow (plate 103) and Lloyd Johnson (plates 101, 105), these textiles with their kitsch appeal, humour and blatant colours were in tune with the prevailing youth culture of the 1960s. Further examples of utilizing contemporary visual material as a source of textile design can be seen in *Lunar Rocket* (plate 97) and *Space Walk* (plate 96) created by Eddie Squires and Sue Palmer to commemorate the moon landing in July 1969. Produced for Warner's 'Centenary' collection, these imaginative textiles serve to illustrate this long-established firm's design policy to 'produce both traditional and new original designs'.[15] Though the sales of both designs were low, *Lunar Rocket*, incorporating some of the most famous images of the space race, has since achieved cult status.

HISTORICAL REVIVAL AND THE ENDURING INFLUENCE OF FLORAL PATTERNS

In contrast to the novelty and up-to-the-minute appeal of space travel and Pop Art, the mid-1960s witnessed the revival of historical styles inspired by decorative motifs borrowed from the Arts and Crafts movement and Art Nouveau. A number of designs sold by leading producers and retailers such as Heal's and Liberty's between 1966 and 1968 satisfied the vogue for *fin de siècle* revivals and reveal ingenious re-workings of the style with new colourings to suit 1960s taste. Peter Hall's *Petrus* (plate 83) for Heal's, for example, subverts the scale of an Art Nouveau flat pattern to portray giant repeating florets and create the illusion of three-dimensional form. The Arts and Crafts revival was boosted by the availability from the 1950s of William Morris's (1834–96) wallpaper designs, reproduced by Sandersons who had acquired the original blocks. Initially manufactured as block-printed wallpapers in keeping with Morris's original intention, some of the designs were later adapted by Sandersons for machine production, thus making them more accessible. Patterns were also adjusted to fit modern furnishing widths and colour preferences, enabling designs to be successfully screen-printed onto cloth. The vogue for the floral Arts and Crafts style at this time was relatively long-lived and is illustrated by another Peter Hall creation entitled *Rosamund* (plate 85). This playful design, which features a large repeating cluster of flowers emerging from 'acanthus-like' foliage, was produced by Heal's as late as 1975. The longevity and popularity of this fashion is perhaps best exemplified, however, by *Daisy Chain* (plate 77) created by freelance designer Pat Albeck, who has a particular flair for floral patterns. This best-selling textile, which relates to William Morris's wallpaper design *Blackthorn*, was to remain in production from 1965 to 1989.

The optimistic image of a simple daisy head became synonymous with the 1960s, and its most famous and long-lived appearance was Mary Quant's black and silver daisy logo designed by Tom Wolsey in the middle years of the decade. Bold, daisy-like florets were incorporated into numerous textile designs like *Quarto* (plate 81), *Volution* (plate 87) and *Verdure* (plate 80). The 1960s spirit of 'Flower Power' also manifested itself in the revival of Elizabethan and Jacobean embroidery designs illustrated by *Prince of Quince* (plate 79) and *Jupiter* (plate 78). Reproductions of the original historical patterns, which were richly embroidered in wools, silks and metal threads, were roller- and screen-printed onto linen and cotton in the psychedelic colours so fashionable in the mid-1960s. During this time Bernard Nevill, while designing for Liberty's, played a key role in the resurgence of the Art Deco style in textile design which was to reach a peak of popularity in 1969. Also finding inspiration in the powerful graphics of the 1920s and 1930s, Celia Birtwell's textile designs on moss crêpe and chiffon were perfect for the romantic, long line dresses created by her husband, the fashion designer Ossie Clark (1942–96). Repeating patterns for dress fabrics echoed the relatively small-scale, stylized floral motifs and linear geometrics found in 1920s and 1930s decorative art, while designers of furnishing fabrics looked to the towering shapes of Art Deco architecture for ideas. Thus *Archway* (plate 88) and *Arcade* (plate 89) refer to the Odeon style of architecture of the inter-war years.

The floral tradition, so much part of the nation's history, continued to be a central feature of textile design in the 1970s. In contrast to the stylized, flat floral devices of the 1960s, *Cottage Garden* (plate 111), first issued in 1974–5, and *Clandon* (plate 110) of 1976–7 were small in scale and naturalistic in appearance. Produced by Liberty of London Prints, these textiles are reminiscent of the semi-realistic designs of the 1909–12 period. *Geranium* (plate 112), another print reflecting this vogue, was produced by the successful (but then relatively new) creative enterprise, Designers Guild. The socio-economic downturn brought about by the oil crisis in 1973 prompted designers to create a series of patterns that were reassuring and brought a sense of comfort and security to the home at a time of considerable uncertainty.

During the first half of the 1980s floral patterns remained fashionable for furnishing textiles, a trend encouraged by a general mood of retrospection and nostalgia and the rapid growth of the heritage industry. In the high street Laura Ashley's Home Furnishings business popularized the English Country House style for the domestic sector, drawing heavily upon traditional floral patterns, while companies such as Warners, G.P. & J. Baker, Sandersons, Osborne & Little and Colefax & Fowler turned to their own archival resources and historical collections for inspiration.

A stylistic turning point came in 1983 when designers Susan Collier and Sarah Campbell launched their '6 Views' collection which achieved great success, winning a Design Council Award in 1984. *Côte D'Azure* (plate 115), produced in bright Mediterranean colours, was inspired by the work of Henri Matisse, and *Havana* (plate 116), depicting a zigzag ribbon pattern which has its roots in the nineteenth century, provided an impetus for change, representing a new confidence, boldness and vision. The influence of this high-profile collection is evident in the textiles that emerged in the second half of the decade. The market was supplied with a succession of exciting printed designs displaying a multitude of ideas, including a popular vogue for *trompe l'oeil* effects seen, for instance, in *Aquarelle* (plate 117) and *Panache* (plate 119). Passementerie, another favoured source of inspiration, was used in a number of interesting repeats, including *London Tassels* (plate 118), which incorporates the furnishing accessories of cords and tassels.

The tradition of commissioning leading artists and sculptors to design textiles, particularly fashionable from the 1940s to 1960s, continued in the later twentieth century. The notion that a famous name would add kudos to the collection and improve sales persisted, and artists were invited to produce designs for special occasions or to promote new dimensions to seasonal collections. In 1983, for example, Warner Fabrics produced *Autograph* (plate 128) and *Water* (plate 127) designed by the artist Howard Hodgkin for the Arts Council exhibition *Four Rooms*, and in 1986 Celia Birtwell commissioned *Punchinellas* from the artist David Hockney for her 'Portobello' collection.

POST-MODERNISM

Some of the most original designs of the mid-1980s to 1990s came from new groups of small yet influential textile companies and individuals including Timney Fowler, English Eccentrics, Timorous Beasties and Neil Bottle. The incorporation of architectural ornament has been one of the strongest themes in Post-Modernist design with textiles such as *Gaudi* (plate 120) and *Fallen Angel* (plate 121), illustrating the revival of Neo-Classical forms, and *Grand Acanthus* (plate 136), making reference to Gothic masonry. Although some

designs such as *Columns* (plate 122) bear a close relationship to the 'pillar prints' of the late eighteenth and nineteenth centuries, others like *Composite* or *Collage* (plate 123) are derived from a mixture of sources and display a highly effective 'cut and paste' format. The use of bold black and white and sympathetically muted shades, together with a clever manipulation of scale, suit the architectonic subject matter, creating powerful furnishing fabrics.

CRAFT TEXTILES

The post-war revival of hand-crafted textiles was promoted by a number of exhibitions which drew attention to the diversity of British talents and attracted a new following for the crafts. Three of these – *Weaving for Walls: Modern British Wall Hangings and Rugs* (1965), *Collingwood/Coper* (1969) and *The Craftsman's Art* (1973) – were held in conjunction with, or organized by, the V&A.

The most adventurous weaving in the 1960s represented a break with traditional techniques and practice. Influential 'new wave' exponents included Tadek Beutlich, Peter Collingwood and Ann Sutton who experimented with materials and techniques to create one-off pieces which reflected their very different approaches. A fascination with 'found' objects and organic material is revealed in Tadek Beutlich's *Moon* (plate 50), which incorporates honesty seed, x-ray film and charred wood into a mesh-like structure of ramie and camel hair. *Macrogauze 26* (plate 51) of 1968 by Peter Collingwood is typical of the highly controlled, complex method of weaving which he developed in the early 1960s. Archie Brennan, while resident designer and head weaver at the Edinburgh Tapestry Company from 1962, was successful in securing the future of traditional tapestry weaving by developing it as a medium for contemporary design in such works as *Chains* (plate 76). In the 1970s the traditional parameters of the art of weaving continued to be extended in seminal pieces like Ann Sutton's *Square Spectrum Spiral* (plate 113) with its interwoven knitted tubes and John Hinchcliffe's highly tactile, rainbow-coloured, rugs and woven wall hangings utilizing the double-corduroy weaving technique (plate 114). Adding new dimensions in the 1980s, Mary Restieaux produced colourful woven wall hangings (plate 129), scarves and belts of ikat silk (warp-dyed

cloth), which were influenced by the painter Johannes Itten's (1888–1967) *Seven Colour Contrasts*, giving, as she explains, 'a sense of movement'.[16] The 1990s has seen a continuation of the use of traditional methods to create new and exciting effects. Gilian Little is one of the designer-makers at the forefront of a trend to 'deconstruct' cloth using felting and devoré (a 'burn-out' patterning process) techniques (plate 150).

Within the confines of surface-decorated textiles Susan Bosence was a central figure in the revival of the craft of block-printing. By the 1960s she had developed her own style of block-printing and indigo-resist dyeing (plates 45–9) inspired by natural forms and landscapes. Her processes resulted in works with an elegant simplicity and unique depth of surface patination. In the field of batik (wax resist-dyed textiles) Michael O'Connell, Stanley Crosland and, in more recent years, Noel Dyrenforth (plate 131) developed the process as a medium for artistic expression.

The 1980s and 1990s witnessed the emergence of a new generation of designer-makers responsible for fresh ideas and an abundance of exciting textiles. Many have concentrated upon the field of fashion fabrics. Pookie Blezard and Suzy Thompson of Pazuki Prints, Susannah Cartwright, Victoria Richards (plate 133), The Cloth (plates 124, 125), Georgina von Etzdorf, Luiven Rivas-Sanchez (plates 142, 143) and Rebecca Earley (plates 140, 141) have successfully supplied the fashion market through such prominent outlets as Paul Smith.

Diana Harrison creates one-off wall hangings using a combination of spray painting and quilting techniques (plate 130). From the mid-1980s the practice of producing dramatic wall-hangings and banners was advanced by Sian Tucker (plate 132), Sally Greaves-Lord (plate 135) and Carole Waller (plate 148), all of whom specialize in painting onto cloth. Other talented individuals working on a large scale to produce decorative works for corporate and domestic interiors include Rushton Aust, Dawn Dupree, Kate Blee, Neil Bottle (plate 134) and Sharon Ting (plate 149). Practitioners such as Nigel Atkinson (plates 144, 145), Jonathan Fuller, Karina Holmes, Gary Rooney, Norma Starszakowna and Janet Stoyel have embraced the opportunity offered by new technology and materials and created an exciting and radically different design aesthetic, as illustrated by the textiles on display at the *Textiles and New Technology 2010* exhibition organized by the Crafts Council in 1994.

In 1977 the international textile authority and designer Jack Lenor Larson stated: 'Britain has by far the best colleges with fabric design courses. Government subsidies seem to be both large and on the whole enlightened.'[17] Certainly in the post-war years enormous advances were made to raise standards in textile design, 'improve' public taste and make 'good' design accessible. Government initiatives, such as the exhibition *Britain Can Make It* held at the V&A in 1946 and organized by the Council of Industrial Design (formed in 1944), helped to emphasize the importance of design within the public consciousness. The 1951 Festival of Britain acted as a further catalyst.

Initiatives such as the Design Centre Awards scheme introduced by the Council of Industrial Design in 1957, together with exhibitions organized or inspired by the Cotton Board's Colour, Design and Style Centre, which opened in Manchester in 1940, proved highly successful in raising the profile of textile design. The Design Centre Awards acted as a seal of quality in the eyes of the consumer, providing kudos for both manufacturer and designer, while the Colour, Design and Style Centre presented a platform for the promotion of young influential designers, including Lucienne Day, Pat Albeck, Doreen Dyall, Shirley Craven, Barbara Brown, Robert Dodd, Colleen Farr, Althea McNish, Howard Carter and Natalie Gibson, all of whom went on to make significant contributions to British textile design. Many of these designers were graduates of the Royal College of Art, London, which became the model for other colleges, receiving its first practising Professor of Textiles, James de Holden Stone, in 1949.

The Design Centre and the Cotton Board furthered the interests of manufactured textiles, while Contemporary Applied Arts, set up in 1948, and the Crafts Advisory Committee, established in 1971 and re-named the Crafts Council in 1979, have provided invaluable support for artist-craftspeople and designer-makers. The magazine *Crafts*, first published by the Crafts Advisory Committee in 1973, has become the leading commentator on the British scene. Of particular significance has been the work carried out in developing markets for the crafts, which, together with the

availability of the Crafts Council setting-up grants, has provided a means for the profession to develop.

Paradoxically the post-war period bears witness to the serious decline in the British textile industry. Despite representing (in conjunction with clothing production) one of the most important sectors of the UK economy, with annual sales of £29 billion, exports of £8 billion and a work-force of 375,000,[18] British textile manufacture, in the face of aggressive foreign competition and world recession, has suffered dramatically from lack of financial investment and official support. This has resulted in a situation whereby mainstream textile manufacture is dictated primarily by market forces which tend to minimize opportunities for design innovation. But as textile designer Susan Collier points out, 'Good design should be available to everybody. It costs just as much to draw, engrave and colour a bad design as it does a good one.'[19]

NOTES

1. Correspondence between Enid Marx and the V&A, 1949.
2. *International Textiles*, October 1945, vol. 9, p. 59.
3. *Ibid.*
4. M. Hartland Thomas, 'Festival Pattern Group', *Design*, May/June 1951, no. 29–30, p. 14.
5. *Ibid.*, p. 20.
6. *Ibid.*
7. Correspondence between Lucienne Day and the V&A, 1996.
8. J. Murray, 'Furnishing Fabrics for the Mass Market', *Design*, December 1950, no. 24, p. 15.
9. A. Morton, 'The Birth of a Furnishing Fabric', *Art and Industry*, April 1941, p. 92.
10. Council of Industrial Design, 'Designs of the Year 1958' *Design*, June 1958, no. 114, p. 28.
11. H. Juda, 'Painting Into Textiles', *The Ambassador*, November 1953, p. 73.
12. Council of Industrial Design, 'Design Centre Awards 1964', *Design*, June 1964, no. 186, p. 54.
13. Advertisement for Heal Fabrics, *The Ambassador*, November 1966, p. 35.
14. Z. Rhodes and A. Knight, *The Art of Zandra Rhodes*, Jonathan Cape, London, 1984, p. 20.
15. Warner Fabrics, *Spring 1993 New Collections*, p. 1.
16. A. Sutton, *British Craft Textiles*, Collins, London, 1985, p. 179.
17. J. Lenor Larson, 'British Textile Designers – The Secret of Successful Competition', *Design*, December 1977, no. 348, p. 28.
18. Figures for 1997 from the British Apparel & Textile Confederation/Office for National Statistics.
19. L. Jobey, 'Learning the Job', *Design*, September 1981, no. 393, p. 44.

Notes on Firms, Designers and Makers

Schools and colleges are situated in London unless otherwise indicated.

ALBECK, PAT (b. 1930). Freelance designer. Studied printed textile design in Hull and at the Royal College of Art in the 1950s. She has worked for many textile companies including Liberty of London Prints and Horrockses and was one of the earliest practitioners to successfully use felt tip pens in the design process. Her best-selling textile design *Daisy Chain* was manufactured by Cavendish Textiles from 1965 to 1989. In 1969 began designing merchandise for the National Trust. Author of *Printed Textiles* (Oxford University Press 1969).

ASCHER LTD London. Textile designers and manufacturers. Founded in 1942 by the husband and wife team of Zika (1910–92) and Lida Ascher (d. 1983) to produce luxury fabrics for the fashion industry. Supplied dress designers including Edward Molyneux, Christian Dior, Elsa Schiaparelli, Lanvin-Castillo and Pierre Cardin in England, France, Italy and America with avant-garde printed and woven fabrics. Known for screen-printed head squares and linen wall panels designed by leading international artists and also responsible for innovative textiles such as mohair fabrics (1957), chenilles (1959), heavy cotton laces (1960), non-wovens (1966), plastic-coated printed-cotton laces (1966) and cheesecloth (1969).

ATKINSON, NIGEL (b. 1964 Hampshire). Textile designer. Studied textiles at Winchester School of Art (1983–6) and in 1987 established his first hand-printing workshop in London's Smithfield Market. Specializes in the production of highly textured fabrics for an international clientele – mainly fashion and interior designers. Launched his accessories label in 1994 and Nigel Atkinson Interior Textiles in 1997.

BEUTLICH, TADEK, MBE (b. 1922 Poland). Weaver. Studied in Poland, Germany and Italy before graduating in textiles from Camberwell School of Art and Crafts (1948–50), where he also taught from 1951 to 1974. First working in traditional tapestry techniques, he next explored open-weave structures incorporating unconventional materials. In 1974 moved to Spain where he developed his off-the-loom three-dimensional works using locally grown esparto grass. His latest creations in the form of woven human figures are produced by the technique of wrapping, using cotton, wool and PVA. Author of *The Technique of Woven Tapestry* (Batsford 1967).

BOSENCE, SUSAN, MBE (1913–96; b. Luton, Bedfordshire). Teacher and producer of block-printed and resist-dyed textiles. Inspired by the textiles of Phyllis Barron and Dorothy Larcher, from whom she learnt her skills. During the 1950s she developed her own work for clothing and domestic use. From the 1960s taught at Dartington Hall School and at the New Adult Education Centre, Dartington, where she planned the dyehouse and printing studio. Taught at Camberwell School of Art and Crafts and West Surrey College of Art and Design, Farnham, until the mid-1980s. Author of *Hand Block-Printing and Resist-Dyeing* (David & Charles 1985).

BOTTLE, NEIL (b. 1966 Ramsgate, Kent). Textile designer and maker. Studied printed textiles at Middlesex Polytechnic (1986–9). His work concentrates on the production of unique hand-painted/printed silk hangings and limited edition furnishing and fashion accessories inspired by 'the process of ageing and the aesthetics of decay' (designer's promotional literature, *c.* 1991). Established a Ramsgate studio in 1991 where he works with his wife Julia Bottle.

BRENNAN, ARCHIE (b. 1931 near Edinburgh). Tapestry weaver and designer. Completed his apprenticeship between 1947 and 1953 at the Dovecot Studios and the Golden Targe Studio, Edinburgh. Worked as resident designer, head weaver and director of the Edinburgh Tapestry Company between 1962 and 1978 where he was chiefly responsible for popularizing the medium, making the company financially viable and bridging the gap between the creative designer and master weaver. His first works were exhibited in Scotland in 1962, the year he established the first Department of Tapestry at Edinburgh College of Art which he ran until 1973. Since 1978 he has worked as a freelance weaver in many parts of the world including Papua New Guinea and the USA.

BROWN, BARBARA (b. 1932 Manchester). Freelance textile designer. Trained at Canterbury College of Art and then at the Royal College of Art from 1953 to 1956. Known for her strong geometric award-winning designs of the 1960s and early 1970s produced chiefly for Heal Fabrics. Taught printed textile design at Medway College of Art, Kent, in the 1960s, and at the Royal College of Art until the early 1990s.

CALICO PRINTERS' ASSOCIATION LTD Manchester. An amalgamation of 46 printing, dyeing and finishing companies formed on 8 November 1899 under the chairmanship of F.F. Grafton. By 1949 the CPA was the largest commission printers in the UK. The Association's strong research department established in 1906 was responsible for the development of the synthetic fibre Terylene in 1941, and in 1947 introduced their Calpreta non-shrink finishing process. In 1968 the CPA merged with Tootal Ltd to form English Calico Ltd, although it remained a separate unit within the holding company's structure until disbanded in the early 1970s.

CAVENDISH TEXTILES LTD London. Founded by W. Halstead on 27 July 1929 as a subsidiary of the John Lewis Partnership. Originally established to convert dress fabrics for the John Lewis department stores, the company commissioned work from several leading textile designers including Lucienne Day and Pat Albeck. Cavendish Textiles is currently responsible for the design, development and converting of all home merchandise, including printed and woven furnishing fabrics, which are sold under the brand label Jonelle. Printing is carried out by Stead McAlpin & Company Ltd, Carlisle.

COLLIER CAMPBELL LTD London. Founded in 1979 as a fabric-converting business by sisters Susan Collier, a self-taught textile designer, and Sarah Campbell, who trained in graphics. They both previously worked for Liberty of London Prints, where Susan Collier was Design and Colour Consultant from 1972. Especially well known for their successful '6 Views' collection which won a Design Council Award in 1984 and was produced under licence by Fischbacher (London) Ltd.

COLLINGWOOD, PETER, OBE (b. 1922 London). Weaver. Trained in the weaving studios of Ethel Mairet, Barbara Sawyer and Alistair Morton from 1950 to 1952, having previously (1946) qualified in medicine. Introduced warp-dominant 'Macrogauzes' using a system of weaving he developed over the winter of 1962–3. Perfected his shaft-switching rug-weaving technique in 1967. He has exhibited and taught extensively in the UK and USA, and his publications include *The Techniques of Rug Weaving* (Faber 1968), *The Techniques of Sprang* (Faber 1974), *The Techniques of Tablet Weaving* (Faber and Faber 1982) and *Textile and Weaving Structures* (Batsford 1987).

CONRAN, SIR TERENCE (b. 1931 Esher, Surrey). Designer, retailer, writer, critic and restaurateur. Studied textiles at the Central School of Arts and Crafts in the late 1940s and, while still a student, printed and sold his own designs. Before setting up Conran Fabrics in the 1950s with his wife Shirley Conran, he worked as a freelance designer supplying designs to firms such as David Whitehead and Gerald Holtom. Founded Habitat retail stores in 1964 which sold a variety of household products including textiles. Author of *Printed Textile Design* (Studio Ltd 1957) among other interior design books.

CONRAN FABRICS LTD London. Founded in the mid-1950s by the husband and wife team of Terence and Shirley Conran (director from 1956 to 1962). The company successfully marketed reasonably priced woven and printed furnishing fabrics designed by the founders, freelance designers and the Conran Design Group. Supplied architects and interior designers including those working on British European Airways' fleet of Viscount planes, the company's first large-scale contract.

CRAVEN, SHIRLEY (b. 1934 Hull, Humberside). Textile designer and teacher. Studied at Hull Regional College of Art (1951–5) and the Royal College of Art (1955–8). From 1960 she worked as Design and Colour Consultant for the avant-garde textile manufacturers Hull Traders and in 1963 became a director of the firm. Noted for her strong abstract textile designs printed by Hull Traders, several of which received

Council of Industrial Design Awards in the 1960s. Taught textile design at Goldsmiths College from the early 1960s until 1994.

CRESTA SILKS LTD Welwyn Garden City, Hertfordshire. Textile manufacturers. Founded in 1929 by Tom Heron (1890–1983), previously managing director of Cryséde Ltd (1926–9) at St Ives, Cornwall. Specialized in the production of innovative block-printed silk dress fabrics designed by leading British painters including Paul Nash and Cedric Morris. Aimed at an upper middle-class market, the textiles were sold through mail order and various Cresta shops. After the Second World War screen-printing was introduced and Tom Heron's son, the painter Patrick Heron, became the main designer from 1944 to 1950. The firm was sold on Tom Heron's retirement in the later 1950s.

CROSLAND, NEISHA (b. 1960 London). Textile designer. Studied graphics and textile design at Camberwell School of Art and Crafts (1980–4) and printed textiles at the Royal College of Art (1984–6). In 1994 established her own textile design company producing furnishings, dress fabrics and accessories, having worked freelance since 1988. Currently designing luxurious printed scarves sold internationally under her own label.

DAVID WHITEHEAD LTD Rawtenstall, Lancashire. Textile manufacturers. Established in 1927 as a branch company of the Whitehead Group, which was formed in 1815 by the brothers David, Thomas and Peter Whitehead. Originally called Seven Seas, the firm later operated under the trade name of David Whitehead Fabrics. By the early 1950s it was noted for its progressive design policy and enterprising marketing strategy pioneered by John Murray, director of furnishing fabrics from 1948 to 1952. Renowned for producing modern textiles at affordable prices, it was taken over by Lonrho in 1970.

DAY, LUCIENNE, RDI (b. 1917 Coulsdon, Surrey). Designer. Studied industrial design at Croydon School of Art (1934–7) and printed textiles at the Royal College of Art (1937–40), and then taught at Beckenham School of Art before going freelance in 1948. Her designs for textiles were produced by numerous manufacturers including Edinburgh Weavers, British Celanese and Heal's (responsible for printing her famous influential design *Calyx* in 1951). Since the late 1970s she has designed large-scale hand-sewn 'Silk Mosaic' wall hangings which have been exhibited internationally.

DESIGNERS GUILD LTD London. A group of shops on the King's Road and an interior design business. Founded in 1970 by the then husband and wife team of Robin and Tricia Guild. Tricia Guild and designer Chris Halsey produced their first range of textiles based upon a collection of Indian hand-printed fabrics. Launched at the opening of the first shop on the King's Road in November 1971, the collection was instantly successful and expanded with co-ordinating wallpapers and furniture. Well known for colourful soft furnishing and accessory ranges which are marketed internationally. Tricia Guild has written several books on colour and design including *Tricia Guild New Soft Furnishings* (Conran Octopus Ltd 1990).

DYRENFORTH, NOEL (b. 1936 London). Batik textile artist and teacher. Studied at Central School of Arts and Crafts (painting and drawing), Goldsmiths College and Sir John Cass School of Art (textiles and ceramics). In 1962 set up his own London studio and commenced working in the medium of batik. He has travelled to destinations such as Australia, China, Indonesia and Japan to exhibit, expand his skills and share his knowledge. Author with John Houston of *Batik with Noel Dyrenforth* (Orbis 1975) and *The Technique of Batik* (Batsford 1988).

EARLEY, REBECCA (b. 1970 Marlborough, Wiltshire). Textile designer and maker. Studied fashion and textiles at Loughborough College of Art and Design (1989–92) and fashion at Central St Martin's School of Art and Design (1992–4). In 1994 established her B. Earley label producing a range of heat-photogram printed scarves and dress fabrics. In 1995 formed the high fashion Earley Palmiero label in partnership with Giovanna Palmiero.

EDINGURGH TAPESTRY COMPANY LTD (DOVECOT STUDIOS)
Edinburgh. Tapestry workshop. Established in 1912 by the 4th
Marquess of Bute, it became an incorporated company after the
Second World War. W. G. Thomson was the first director and
the first two master weavers came from William Morris's
Merton Abbey workshop. From 1912 to 1939 the workshops,
which became known as Dovecot Studios, produced large-scale
'traditional' tapestries for the Marquess of Bute. After the
Second World War, began to produce artist-designed tapestries.
The company, which is commission-led, has recently
diversified to make rugs and wall hangings produced by
the tufting-gun process.

EDINBURGH WEAVERS LTD Carlisle, Cumbria. Textile
manufacturers. Founded in 1929 by James Morton (1867–1943)
as an experimental design and marketing unit of Morton
Sundour Fabrics (established 1914). Originally based
in Edinburgh, the firm merged with Morton Sundour Fabrics'
weaving factory, Carlisle, in 1930. Achieved success in the UK
and USA under the enlightened design directorship of Alistair
Morton (1910–63) who commissioned freelance designers and
artists to produce work for interpretation by the unit. Taken
over by Courtaulds in 1963.

ENGLISH ECCENTRICS London. Textile and fashion designers.
Founded in 1982 by Helen David (née Littman), Judy Littman
and Claire Angel. Under the creative direction of Helen David
(b. 1955), who studied fashion design at Camberwell School
of Art and Crafts and graduated in 1977, the company has
developed a reputation for exclusive ranges of eclectic textile
designs printed onto luxurious fabrics. Re-named Helen David
English Eccentrics in 1996.

GREAVES-LORD, SALLY (b. 1957 Sutton Coldfield, West
Midlands). Designer-maker. Studied textiles at West Surrey
College of Art and Design, Farnham (1977–80), and at the
Royal College of Art, graduating in 1982, when she set up her
first workshop in London. From 1985 to 1991 worked as
creative director at Issey Miyake UK Ltd. Renowned for hand-
painted and discharge-printed silk banners of large-scale
abstract imagery inspired by landscapes. In the 1980s worked
in a dramatic self-imposed neutral palette of black, greys and
browns but since moving to north Yorkshire in 1991 she has
introduced vibrant colour.

GROAG, JACQUELINE, RDI (1903–86; b. Prague, Czechoslovakia).
Freelance designer. Studied at Vienna's Kunstgewerbeschule in
the early 1920s and produced designs for the Wiener
Werkstätte. Emigrated to France in 1937 where she designed
dress fabrics for Lanvin and Schiaparelli. Finally settled in the
UK in 1939, working for several leading textile manufacturers
including David Whitehead, Liberty's, Heal's and Sandersons.

HARRISON, DIANA (b. 1950 London). Textile artist and
teacher. Studied embroidery at Goldsmiths College (1967–71)
and printed textiles at the Royal College of Art (1971–3).
Specializes in the production of quilted and hand-dyed wall
hangings, cushions and bed-quilts of subtle geometric design.
In 1974 began teaching at West Surrey College of Art and
Design, Farnham.

HEAL FABRICS LTD London. Textile company. Founded in 1941
as a subsidiary of the long-established firm Heal & Son, and
originally known as Heal's Wholesale and Export Ltd. After the
Second World War the company began to specialize in
furnishing fabrics and in 1958 changed its name to Heal
Fabrics. Under the visionary direction of Tom Worthington
from 1948 to 1971, the company secured a worldwide
reputation for issuing well-designed contemporary fabrics
which were particularly popular in the 1950s and 1960s.
Textiles were sold from Heal's shop in Tottenham Court Road,
among other UK retail outlets, and internationally by various
distributors including Heal Textil GmbH in Germany,
established in 1964.

HELIOS LTD Bolton, Lancashire. Textile manufacturers.
Formed in 1936 as an independent subsidiary of the long-
established textile firm of Barlow & Jones Ltd, the company was
the brainchild of Sir Thomas Barlow (managing director of the
parent company), who was committed to raising standards in
industrial design. Marianne Straub (1909–94), as head
designer from 1937 and managing director from 1947, was
largely responsible for the success of this forward-looking
company known for its ranges of woven and printed
furnishings. Bought by Warner & Sons in 1949.

HINCHCLIFFE, JOHN (b. 1949 Sussex). Trained at Camberwell School of Art and Crafts (1968–71) and the Royal College of Art (1971–3). Achieved recognition as a textile artist early in his career for the production of his richly coloured rag rugs, winning a Daily Telegraph Magazine British Craft Award for textiles in 1977. Since the early 1980s he has made decorative ceramics in partnership with Wendy Barber, painter and tapestry weaver. With Angela Jeffs author of *Rugs from Rags* (Orbis 1978).

HULL TRADERS LTD Trawden, Lancashire. Textile manufacturers. Founded by Tristram Hull in 1957 to produce short runs of screen-printed avant-garde furnishing fabrics. In 1961 the business moved from Willesden, London, to Lancashire, taking up occupancy of Pave Shed, an empty mill near Colne. Successfully guided by Shirley Craven as design and colour consultant and Peter Neubert the managing director, the company was awarded several Design Centre Awards. Specialized in large-scale abstract designs. In 1980 the company became part of Badehome Ltd which was dissolved in 1982.

JACQMAR London. Textile manufacturers and London fashion house. Listed in the commercial directories from 1936 to 1972 as Jacqmar Fabrics (1936) and Jacqmar Ltd Fabrics (1942), this branch of the company specialized in the production of luxury silk scarves. The company gained a reputation for quality printed head squares through the 1940s and 1950s and were noted for their patriotic scarves illustrating aspects of wartime Britain, which were first issued in 1941.

LIBERTY & Co. LTD London. Regent Street department store and retail business, which was founded in 1875 by Arthur Lasenby Liberty (1843–1917) and became a limited company in 1894. Famed for their Liberty Art Fabrics and best-selling floral dress designs printed from the 1930s on the lightweight cotton known as 'Tana Lawn'. In 1939 Liberty of London Prints Ltd was formed to cope with the success and growing demand for this branch of the company's merchandise. From 1904 until 1973 printing was carried out at their Merton Abbey printworks (previously owned by Edmund Littler) and then by other UK printers including Stead McAlpin & Company Ltd.

In 1982 Liberty's re-registered as a public limited company and in 1996 Osborne & Little bought the distribution rights to Liberty Furnishings.

LITTLE, GILIAN (b. 1962 London). Textile designer-maker. Studied woven textiles at West Surrey College of Art and Design, Farnham (1987–90), and at the Royal College of Art (1990–3). Set up own workshop in 1994 to concentrate on designing woven and knitted textiles sold for conversion to industrial production. She also creates limited edition hangings and accessories sold under her own label. Her work, primarily inspired by organic matter and distressed architecture, is produced in a neutral palette of grey, cream and beige.

MAHLER, MARIAN (c. 1911–83; b. Austria). Freelance textile designer. Studied in Vienna at the Kunstgewerbeschule from 1929 to 1932 and at the Royal State Academy. In 1937 emigrated to Britain where she worked for various leading textile manufactureres including Allan Walton, Edinburgh Weavers and Donald Brothers. Known for her Contemporary-style printed furnishings produced by David Whitehead Ltd in the 1950s.

MARX, ENID, RDI (1902–98; b. London). Artist, craftswoman and designer. Studied fine art, textiles and ceramics at Central School of Arts and Crafts and painting at the Royal College of Art in the 1920s. From 1925 worked for the textile designers and printers Barron and Larcher and developed her own block-printed textiles using natural dyes – her primary focus until the Second World War. Her first designs for woven textiles were seating moquettes for the London Passenger Transport Board produced in 1937. During the 1940s she continued to design industrially woven upholstery fabrics for the Design Panel of the Utility Furniture Advisory Committee set up by Gordon Russell in 1943. Throughout her career she produced designs for a variety of media including books, wallpapers, postage stamps and ceramics, alongside her own artwork. In conjunction with historian Margaret Lambert, she published books, *When Victoria Began to Reign* (1937), *English Popular and Traditional Art* (1946) and *English Popular Art* (1951).

MORTON SUNDOUR FABRICS LTD Carlisle, Cumbria. Textile manufacturers. Established in 1914 following the success of the guaranteed 'unfadable' fabrics initially manufactured by Alexander Morton & Co. and sold under the brand name of Sundour. In its first year the company took over most of Alexander Morton & Co.'s production except for carpets, machine-made lace and muslins. Under the dynamic direction of James Morton (1867–1943), the second son of Alexander Morton (1844–1921), the company became renowned for affordable, durable furnishings in addition to its Sundour ranges. Merged with Edinburgh Weavers, the company's experimental branch, before take-over by Courtaulds in 1963.

OK TEXTILES LTD London. Textile designers and printers. Founded by designer/directors Jane Wealleans and Sue Saunders in the early 1970s. Working under the snappy slogan of 'If it runs we chase it', the firm concentrated on short runs of fashion and furnishing fabrics.

RESTIEAUX, MARY (b. 1945 Norwich, Norfolk). Weaver and dyer. Studied textiles at Hammersmith School of Art (1969–72) and the Royal College of Art (1972–4). Specializes in ikat silk weavings produced as hangings, scarves and belts. Her textiles are characterized by geometric designs produced in bold and lively colours. In 1974 she began teaching at various major art and design colleges in London, including Central School of Art and Design and Goldsmiths College, and also at West Surrey College of Art and Design, Farnham.

RHODES, ZANDRA, RDI (b. 1940 Chatham, Kent). Textile and fashion designer. Studied printed textiles at Medway College of Art (1959–61) and then at the Royal College of Art (1961–4). Set up first print studio in London with Alex MacIntyre and sold her textiles direct to fashion designers before launching the Rhodes & Ayton fashion label with merchandise sold through the Fulham Road Clothes Shop which opened in 1967. In the 1970s her furnishing textiles were marketed through 'By the Yard by the Yard', the wholesale company she set up with interior designer Christopher Vane Percy, and in the 1980s by Osborne & Little. Rhodes produced her first solo fashion collection in 1969 and is renowned for her painterly screen-printed and hand-decorated textiles. Author, with Anne Knight, of *The Art of Zandra Rhodes* (Jonathan Cape 1984).

RICHARDS, VICTORIA (b. 1964 Exeter, Devon). Textile designer-maker. Graduated from West Surrey College of Art and Design, Farnham, in 1985. Set up first workshop in 1986 at Clockwork Studios, London, where she concentrated on commissioned work for the fashion industry. Her current work, produced under her own label, combines printed and painted abstract designs in rich colourings for the fashion market. Teaches on the Foundation Course at Wimbledon School of Art.

RIVAS-SANCHEZ, LUIVEN (b. 1957 Venezuela). Textile designer-maker. Graduated in fashion and textiles from St Martin's School of Art and Design in 1985 having previously studied medicine. Since working as assistant designer to Katharine Hamnett from 1985 to 1987, he has designed dress fabrics for other leading international fashion designers including Jasper Conran, John Galliano and Christian Lacroix. Rivas-Sanchez produces exclusive hand-printed and decorated high fashion fabrics.

SANDERSON, ARTHUR & SONS LTD Uxbridge, Middlesex. Wallpaper and textile manufacturers. Founded in 1860 by Arthur Sanderson (d. 1882), the company originally specialized in the manufacture of wallpapers but began to produce and market textiles shortly after the First World War. From 1921 printed textiles were manufactured at the Uxbridge factory, joined by weaving production in 1934. Initially known as Eton Rural Cretonnes, Eton Rural Fabrics from *c.* 1922 and Sanderson Fabrics from 1936, this successful branch of the company is noted for quality furnishing textiles created by the Sanderson Studio and freelance artists and designers.

SQUIRES, EDDIE (1940–95; b. Grimsby, Humberside). Textile designer. Trained at Grimsby School of Art (1956–9) and the Central School of Arts and Crafts, graduating in 1962. In 1963 joined Warner & Sons. In 1971 he became chief designer and a director of the company from 1984 to 1993. Throughout his career he enthusiastically promoted contemporary textile design and actively supported the development of creative talent through the work of the studio and by commissioning work from up-and-coming designers. An original and witty designer in his own right, he is particularly noted for his *Lunar Rocket* textile design produced to commemorate the moon landing in 1969.

STRAUB, MARIANNE, RDI, OBE (1909–94; b. Amriswil, Switzerland). Textile designer, weaver and teacher. Studied hand weaving at Zurich's Kunstgewerbeschule (starting in 1928) and mechanized weaving in 1932–3 at Bradford Technical College in the UK (Swiss technical colleges did not accept women). Worked as consultant designer for the Rural Industries Bureau (1934–7); head designer (1937–47) and then managing director (1947–9) of Helios; and head designer of Warner & Sons (1950–69). Her pioneering work in industry was complemented by an extensive period of lecturing at Central School of Art and Design, Hornsey College of Art and the Royal College of Art from 1956 to 1974. Author of *Hand Weaving and Cloth Design* (Pelham Press 1977).

SUTTON, ANN (b. 1935 Staffordshire). Textile designer and maker. Studied embroidery and weaving at Cardiff College of Art from 1951 to 1956. Renowned for her progressive approach to weaving techniques. Although a producer of one-off textiles, she has also adapted her conceptual methods to weaving for serial production. She has exhibited and written extensively within her field and her publications include *Tablet Weaving* (Batsford 1978), *The Structure of Weaving* (Hutchinson 1982), *Colour-and-Weave* (Bellew 1984) and *British Craft Textiles* (Collins 1985).

TEXTRA FURNISHING FABRICS LTD London. Founded in 1963 by Malcolm Mackinnon and Richard Jenkins as a textile design and distribution organization supplying printed and woven furnishing fabrics to European and American markets. Textra Furnishings achieved a balance between high standards of design and commercial enterprise. Now known as Textra Contracts Ltd.

THE CLOTH LTD London. Textile and fashion designers. Established in 1983 by Helen Manning, Fraser Taylor, Brian Bolger and David Band, all of whom studied printed textiles at the Royal College of Art (1981–3). The designers shared a common interest in fine art and were successful in producing distinctive, painterly printed fabrics used from 1984 in their own high fashion clothes ranges and by other designers including Jeff Banks, Paul Smith and Joseph. In their short existence as a group, they were also engaged in other creative pursuits ranging from interior decoration schemes and window displays to book illustration and graphic design. The company disbanded in 1987.

TIMNEY FOWLER LTD London. Textile manufacturers and interior design business. The Timney Fowler partnership was formed in 1979 by Sue Timney (b. 1950) and Grahame Fowler (b. 1956), who studied textiles at the Royal College of Art (1977–9). Became a limited company in 1985. Known especially for their striking black and white ranges, the first of which, the 'Neo Classical' collection, was officially launched in 1985. To accommodate the rapid expansion of the company's merchandise and services – ranging from the production of fabrics, wallpapers and accessories to specialist design consultancy – the Timney Fowler Design Studio was set up in 1993 as a separate branch of the parent company.

TIMOROUS BEASTIES LTD Glasgow. Textile designers and makers. A textile design partnership formed in 1990 by Alistair McAuley (b. 1967) and Paul Simmons (b. 1967). Both had studied textiles at Glasgow School of Art, and Simmons also attended the Royal College of Art between 1988 and 1990. Their early printed designs were characterized by vivid colour and dramatic large-scale fauna and flora derived from illustrated encyclopaedias. A limited company from 1997, it currently produces two collections per year together with one-off designs commissioned by international interior designers.

TING, SHARON (b. 1968 London). Textile designer-maker. Studied printed textiles at West Surrey College of Art and Design, Farnham (1987–90), and at the Royal College of Art (1990–2). In November 1992 set up her own workshop where she creates designs for industrial production alongside a craft-based collection of wall hangings and fashion accessories. Her richly coloured luxurious fabrics are produced in abstract designs using various techniques including screen-printing, painting and devoré.

TUCKER, SIAN (b. 1958 Norwich, Norfolk). Textile designer and maker. Studied textiles at Middlesex Polytechnic (1977–80) and at the Royal College of Art (1980–2). After graduating she set up her own workshop where she developed a highly distinctive style of painting directly onto cloth using 'sunny' Mediterranean colours. Her work, characterized by abstract as well as representational forms derived from nature, includes scarves, dress fabrics, screens and hangings. Since the late 1980s she has concentrated on commissions for public spaces. One of her largest projects was for the Chelsea and Westminster Hospital in London for which she produced several painted wall hangings and designed a large-scale mobile.

WALLER, CAROLE (b. 1956 Birmingham). Painted textile artist. Studied painting at Canterbury College of Art (1975–8) and art fibres at Cranbrook Academy of Art in Michigan, USA (1980–2). Produces painted textiles as wall hangings, screens and fashion accessories. In 1986 began creating unique painted garments sold under the name 'I'm No Walking Canvas'. Strong figurative imagery and vibrant colour characterize her work.

WARNER & SONS LTD London; Braintree, Essex; Milton Keynes, Buckinghamshire. Founded in 1870 as a silk-weaving company in Spitalfields, London, by Benjamin Warner (1828–1908), it became a limited company in 1928. One of the best-known producers of high quality domestic woven and printed furnishings, they have also undertaken many commissions from the interior decoration trade including historic houses and royal residences. In 1970 the company was purchased by Greeff Fabrics Inc., the first of a series of take-overs and mergers experienced by the firm. Warner & Sons Ltd re-registered as Warner Fabrics plc in 1987 and from 1989 their activities have centred on their Milton Keynes headquarters while still maintaining a showroom in London. Now owned by Walker Greenbank plc.

PLATES

Measurements are approximate and refer to the size of the object unless stated otherwise. The number of colourways in which a textile has been produced is given where known.

1. *Victory V*, dress fabric, printed cotton
Produced by the Calico Printers' Association, Manchester, 1941; the border of the design illustrating three dots and a dash represents the Morse code for 'victory'
121 x 41cm
Circ 510-1974

2. *Careless Talk Costs Lives*, handkerchief, printed silk, *c.* 1943
Design based on Fougasse's 'Careless Talk Costs Lives' series of Second World War propaganda posters published by the Ministry of Information in February 1940
34 x 32cm
T 95-1986

3. *Coupons*, dress fabric, printed rayon crêpe
Produced by the Calico Printers' Association, Manchester, *c.* 1941–2; inspired by wartime clothes rationing introduced in June 1941
Repeat 38 x 41cm
Circ 509-1974

4. *London Wall*, headscarf, printed rayon
Produced by Jacqmar Ltd Fabrics, London, *c.* 1942
94.5 x 96.5cm
T 290-1987

5. *Careless Talk Costs Lives*, detail of dress fabric, printed rayon crêpe, *c.* 1943
Derived from Fougasse's 'Careless Talk Costs Lives' series of Second World War propaganda posters published by the Ministry of Information in February 1940
Repeat 25 x 19cm, at least two colourways
Circ 74-1975

6. *Ring*, furnishing fabric, woven cotton and condensed yarn
Designed by Enid Marx for the Board of Trade Utility Design Panel, 1945; manufactured by Morton Sundour Fabrics Ltd, Carlisle
Repeat 7.5 x 8cm
Circ 217-1949

7. *Honeycomb*, furnishing fabric, woven cotton and condensed yarn
Designed by Enid Marx for the Board of Trade Utility Design Panel, 1947; manufactured by Morton Sundour Fabrics Ltd, Carlisle
Repeat 10 x 14cm
Circ 215-1949

8. *Spot and Stripe*, furnishing fabric, woven cotton and condensed yarn
Designed by Enid Marx for the Board of Trade Utility Design Panel, 1945; manufactured by Morton Sundour Fabrics Ltd, Carlisle
Repeat 10 x 8cm, trialled in twelve colourways
Circ 221F-1949

9. *Chevron*, furnishing fabric, woven cotton and condensed yarn
Designed by Enid Marx for the Board of Trade Utility Design Panel, 1946; manufactured by Morton Sundour Fabrics, Carlisle
Repeat 10 x 8cm, three colourways
Circ 203A-1949

10. *Totley*, furnishing fabric, dobby woven rayon
Designed by Marianne Straub for Helios Ltd, Bolton, 1947
Repeat 46.5 x 32cm
Circ 77-1947

11. Swatch of dress fabrics, screen-printed rayon
Designed by Eric Stapler for Ascher Ltd, London, 1945
Largest sample 6 x 5.5cm
T 137c-1988

12. Swatch of dress fabrics, screen-printed rayon
Designed by Eric Stapler for Ascher Ltd, London, 1945
Largest sample 4 x 4cm
T 137D-1988

13. *Web*, dress fabric, screen-printed rayon crêpe
Designed by Graham Sutherland (1903–80) for Cresta Silks
Ltd, Welwyn Garden City, 1947
Repeat 19cm high
Circ 105-1947

14. Dress fabric, screen-printed spun rayon
Designed by Julian Trevelyan (1910–88) for Ascher Ltd,
London, 1946
Repeat 19.5cm high
Circ 95B-1947

15. *Aztec*, dress fabric, screen-printed rayon
Designed by Patrick Heron (b. 1920) for Cresta Silks Ltd,
Welwyn Garden City, 1947
Repeat 12.5 x 13cm
Circ 106E-1947

16. *Piano* or *Keyboard*, sample of dress fabric,
screen-printed rayon
Designed by Henry Moore (1898–1986) for Ascher Ltd,
London, 1948
39.5 x 36.5cm
T 94-1992

17. Dress fabric, screen-printed rayon
Designed by Henry Moore (1898–1986) for Ascher Ltd,
London, c. 1945
93 x 38cm, at least nine colourways
T 402A-1980

18. *Wigwam*, dress fabric, screen-printed spun rayon
Designed by Mary Duncan for Cresta Silks Ltd, Welwyn
Garden City, 1947
Repeat 19.5cm high
Circ 107-1947

19. *Jungle*, furnishing fabric, screen-printed spun rayon
Designed by Feliks Topolski (1907–89) for Ascher Ltd,
London, c. 1946
Repeat 87.5 x 59.5cm
Circ 418-1948

20. *Sutherland Rose*, furnishing fabric, screen-printed cotton
Designed by Graham Sutherland (1903–80), 1940;
manufactured by Helios Ltd, Bolton, 1946; featured at the
Britain Can Make It exhibition held at the V&A in 1946
Repeat 19.5cm high
Circ 71-1947

21. *Festival of Britain*, furnishing fabric, screen-printed
rayon satin
Designed by John Barker for David Whitehead Ltd,
Rawtenstall, 1951; produced to commemorate the Festival
of Britain in 1951, the design also makes reference to
the 1851 Great Exhibition by incorporating silhouettes
of the Crystal Palace
Repeat 38.5cm high
T 288-1982

22. *Plankton*, wall covering, screen-printed cotton
Designed by Gerald Holtom for Gerald Holtom Ltd, London,
1951; used by the Design Research Unit in the Dome of
Discovery at the Festival of Britain
165 x 123cm
Circ 225-1951

23. *Orthoclase*, furnishing fabric, woven linen
Produced by the Old Bleach Linen Company Ltd, Randalstown,
Northern Ireland, for the Festival Pattern Group in 1951;
design based on the crystal-structure diagrams for orthoclase
Repeat 10.5 x 16.5cm
Circ 65-1952

24. *Hydrargillite*, furnishing fabric, woven linen
Produced by the Old Bleach Linen Company Ltd,
Randalstown, Northern Ireland, for the Festival Pattern
Group in 1951; design based on the crystal-structure
diagrams for hydrargillite
Repeat 22.5 x 16.5cm
Circ 64-1952

25. *Helmsley*, furnishing fabric, jacquard woven cotton
Designed by Marianne Straub for Warner & Sons Ltd,
London, 1951; inspired by the crystal-structure diagram for
nylon; the shaded circles represent atoms at different levels
within the structure
Repeat 40.5 x 28.5cm
Circ 308-1951

26. *Chalk*, sample of woven tie silk
Designed by Bernard Rowland and manufactured by
Vanners & Fennell Ltd, Suffolk; produced for the Festival
Pattern Group in 1951; design based on the crystal-structure
diagram for chalk
Repeat 5 x 4cm
T 446F-1977

27. *Insulin*, sample of woven tie silk
Designed by Bernard Rowland and manufactured by
Vanners & Fennell Ltd, Suffolk; produced for the Festival
Pattern Group in 1951; design based on the crystal-structure
diagram for insulin
Repeat 7.5 x 4.5cm
T 446F-1977

28. *Haemoglobin*, dress fabric, screen-printed cotton
Produced by Barlow & Jones Ltd, Manchester, for the
Festival Pattern Group in 1951; design based on the
crystal-structure diagram for haemoglobin
Repeat 10 x 5.5cm wide
Circ 77-1968

29. *Haemoglobin*, sample of woven tie silk
Designed by Bernard Rowland and manufactured by
Vanners and Fennell Ltd, Suffolk; produced for the Festival
Pattern Group in 1951; design based on the crystal-structure
diagram for haemoglobin
Repeat 4 x 3.75cm
Circ 72-1968

30. *Afwillite*, sample of furnishing fabric,
screen-printed rayon
Designed by S. M. Slade and manufactured by British
Celanese Ltd; produced for the Festival Pattern Group
in 1951; design based on the crystal-structure diagrams
for Afwillite
41 x 23.5cm, four colourways
Circ 75C-1968

31. *Surrey*, furnishing fabric, jacquard woven wool,
cotton and rayon
Designed by Marianne Straub for Warner & Sons Ltd,
London, 1951; design based on the crystal-structure diagram
for Afwillite; chosen as the curtain fabric for the Regatta
Restaurant on the South Bank, the focal point for the display
of crystal-patterned products at the Festival of Britain
Repeat 78.5cm high, two colourways
Circ 306-1951

32. Furnishing fabric, screen-printed cotton crêpe
Designed by Marian Mahler for David Whitehead Ltd,
Rawtenstall, 1952
Repeat 33.5 x 40cm
Circ 8-1953

33. Furnishing fabric, roller-printed spun rayon
Designed by Jacqueline Groag for David Whitehead Ltd,
Rawtenstall, 1952
Repeat 30 x 23cm
Circ 12-1953

34. Furnishing fabric, roller-printed spun rayon
Designed by J. Feldman for David Whitehead Ltd,
Rawtenstall, 1954
Repeat 23 x 30cm
Circ 504-1954

35. Furnishing fabric, roller-printed spun rayon
Designed by Jacqueline Groag for David Whitehead Ltd,
Rawtenstall, 1952
Repeat 43 x 39cm, five colourways
Circ 13-1953

36. *Mobile*, furnishing fabric, screen-printed rayon satin
Designed by June Lyon for Heal's Wholesale & Export Ltd,
London, 1954
Repeat 60 x 61cm
Circ 208-1954

37. Detail of curtain, screen-printed cotton crêpe
Designed by Marian Mahler for David Whitehead Ltd,
Rawtenstall, *c.* 1952
Repeat 42.5 x 37cm
T 504:2-1996

38. *Totem*, detail of curtain, screen-printed rayon
Designed by Terence Conran for Gerald Holtom Ltd,
London, 1951
Repeat 34 x 44cm
Circ 226-1951

39. *Chequers*, furnishing fabric, screen-printed cotton satin
Designed by Terence Conran for David Whitehead Ltd,
Rawtenstall, 1951; featured at the Festival of Britain in 1951
Repeat 39 x 40.5cm
Circ 283-1951

40. *Calyx*, furnishing fabric, screen-printed linen
Designed by Lucienne Day for the Festival of Britain in 1951;
manufactured by Heal's Wholesale & Export Ltd, London; won
Gold Medal at the Milan Triennale in 1951 and the International
Award of the American Institute of Decorators for best textile
design in 1952
Repeat 68.5 x 61cm, four colourways
Circ 190-1954

41. *Rig*, furnishing fabric, screen-printed linen
Designed by Lucienne Day for Heal's Wholesale & Export Ltd,
London, 1953
Repeat 50.5 x 29cm
Circ 53-1953

42. *Graphica*, furnishing fabric, screen-printed cotton
Designed by Lucienne Day for Heal's Wholesale & Export Ltd,
London, 1954; awarded the Gran Premio at the 10th Milan
Triennale in 1954 in conjunction with three other designs –
Spectators, *Linear* and *Ticker-Tape*
Repeat 48 x 40.5cm
Circ 211-1954

43. *Perpetua*, furnishing fabric, screen-printed rayon taffeta
Designed by Lucienne Day for British Celanese Ltd, 1953
Repeat 49 x 30cm, four colourways
Circ 385-1953

44. *Miscellany*, furnishing fabric, screen-printed rayon taffeta
Designed by Lucienne Day for British Celanese Ltd, 1953
Repeat 61 x 50cm
Circ 383-1954

45. Block-printed and indigo resist-dyed cotton
Susan Bosence, *c.* 1960
Repeat 2.75 x 5.5cm
Circ 289-1961

46. Sample, indigo tie-dyed and sewn cotton
Made under the direction of Susan Bosence, *c.* 1961
87 x 59.5cm
Circ 104-1962

47. Sample, indigo tie-dyed cotton
Made under the direction of Susan Bosence, *c.* 1961
91 x 70cm
Circ 95-1962

48. Sample, indigo tie-dyed cotton
Made under the direction of Susan Bosence, *c.* 1961
73 x 59.5cm
Circ 97-1962

49. Sample, indigo tie-dyed cotton
Made under the direction of Susan Bosence, *c.* 1961
90.5 x 83cm
Circ 98-1962

50. *Moon*, hanging, woven ramie and camel-hair with inserts of honesty seeds, x-ray film and charred wood veneer
Tadek Beutlich, *c.* 1963; exhibited in the travelling exhibition *Weaving for Walls: Modern British Wall Hangings and Rugs* which opened at the V&A in 1965
126 x 59cm
Circ 1180-1967

51. *Macrogauze 26*, hanging, woven black and natural linen with stainless steel rods
Peter Collingwood, 1968; exhibited in the travelling exhibition *Collingwood/Coper*, which opened at the V&A in January 1969
213 x 63cm
Circ 211-1969

52. *Crystalline Image*, furnishing fabric, jacquard woven cotton and rayon
Designed by Alan Reynolds for Edinburgh Weavers Ltd, Carlisle, 1962
Repeat 59 x 63cm, one colourway
Circ 325-1963

53. *Stones of Bath*, furnishing fabric, screen-printed cotton satin
Designed by John Piper (1903–92) for Sanderson Fabrics Ltd, Uxbridge, *c.* 1962
Repeat 54 x 121cm, initially two colourways
T 503:2-1996

54. *Northern Cathedral*, furnishing fabric, screen-printed cotton satin
Designed by John Piper (1903–92) for Sanderson Fabrics Ltd, Uxbridge, 1961
Repeat 54.5cm high, two colourways
Circ 586-1963

55. *Warriors*, furnishing fabric, jacquard woven wool
Designed by Elizabeth Frink (1930–93) for Edinburgh Weavers Ltd, Carlisle, 1960
Repeat 106cm high, one colourway
Circ 1-1961

56. *Avon*, furnishing fabric, screen-printed cotton and rayon satin
Designed by Cecil Collins (1908–89) for Edinburgh Weavers, Carlisle, 1960; commissioned by the Ministry of Works for the New Conference Hall at the British Embassy in Washington, USA; design makes reference to characters in Shakespeare's plays
Repeat 445cm high, one colourway
Circ 685-1966

57. *Adam*, furnishing fabric, jacquard woven cotton and rayon
Designed by Keith Vaughan (1912–77) for Edinburgh Weavers Ltd, Carlisle, 1958; won a Council of Industrial Design Award in 1958
Repeat 101cm high
Circ 466-1963

58. *Cavallo*, furnishing fabric, jacquard woven cotton and rayon
Designed by Marino Marini (1901–80) for Edinburgh Weavers Ltd, Carlisle, 1960
Repeat 99.5cm high
Circ 295-1960

59. *Riders*, furnishing fabric, screen-printed linen
Designed by Marino Marini (1901–80) for Edinburgh Weavers Ltd, Carlisle, 1960
Repeat 94.5cm high
Circ 692-1966

60. *Inglewood*, furnishing fabric, jacquard woven cotton and rayon
Designed by Humphrey Spender for Edinburgh Weavers Ltd, Carlisle, 1959; won a Council of Industrial Design Award in 1959
Repeat 36 x 31cm, three colourways
Circ 465-1963

61. *Sunflower*, furnishing fabric, screen-printed cotton crêpe
Designed by Howard Carter for Heal Fabrics Ltd, London, 1962; won a Council of Industrial Design Award and Cotton Board Award in 1962
Repeat 133cm high, eight colourways
Circ 598-1963

62. *Division*, furnishing fabric, screen-printed cotton satin
Designed by Shirley Craven for Hull Traders Ltd, Trawden,
1964; won a Council of Industrial Design Award in 1964
Repeat 94cm high, three colourways
Circ 121B-1965

63. *Focus*, furnishing fabric, screen-printed cotton satin
Designed by Doreen Dyall for Heal Fabrics Ltd, London, 1965
Repeat 75cm high
Circ 255-1967

64. *Shape*, furnishing fabric, screen-printed cotton satin
Designed by Shirley Craven for Hull Traders Ltd, Trawden,
1964; won a Council of Industrial Design Award in 1964
Repeat 96cm high, three colourways
Circ 121E-1965

65. *Wild Bloom*, furnishing fabric, screen-printed cotton satin
Designed by Doreen Dyall for Hull Traders Ltd, Trawden,
c. 1965
Repeat 74cm high
T 162-1989

66. *Five*, furnishing fabric, screen-printed linen and cotton
Designed by Shirley Craven for Hull Traders Ltd, Trawden,
1966
Repeat 88cm high, four colourways
Circ 760-1967

67. *Simple Solar*, furnishing fabric, screen-printed cotton satin
Designed by Shirley Craven for Hull Traders Ltd, Trawden,
1968; won a Council of Industrial Design Award in 1968
Repeat 77cm high, four colourways
Circ 791-1968

68. *Oeta*, furnishing fabric, jacquard woven ramie,
wool and cotton
Designed by Victor Vasarely (1908–97) for Edinburgh
Weavers Ltd, Carlisle, 1962
Repeat 159cm high
Circ 694-1966

69. *Recurrence*, furnishing fabric, screen-printed cotton crêpe
Designed by Barbara Brown for Heal Fabrics Ltd, 1962;
created to be hung with a similar textile entitled *Reciprocation*;
won a Gold Medal at the Californian State Fair in Sacramento,
USA (1963)
Repeat 73 x 57.5cm, five colourways
Circ 657-1962

70. *Expansion*, furnishing fabric, screen-printed cotton satin
Designed by Barbara Brown for Heal Fabrics Ltd, London,
1966
Repeat 57cm high
Circ 269-1967

71. *Impact*, furnishing fabric, screen-printed cotton
Designed by Evelyn Brooks for Heal Fabrics Ltd, London,
1965; won the *House and Garden*/Cotton Board Award in 1965
Repeat 117cm high, one colourway
Circ 250-1967

72. *Spiral*, furnishing fabric, screen-printed cotton
Designed by Barbara Brown for Heal Fabrics Ltd, London,
1969; won a Council of Industrial Design Award in 1970
Repeat 48cm high, one colourway
Circ 784-1969

73. *Nearing Circles*, furnishing fabric, jacquard woven
wool and linen
Designed by William Scott (1913–89) for Edinburgh Weavers
Ltd, Carlisle, 1962
Repeat 111cm high, one colourway
Circ 324-1963

74. *Megalith*, furnishing fabric, jacquard woven
cotton and rayon
Designed by Alan Reynolds for Edinburgh Weavers Ltd,
Carlisle, 1964
Repeat 141cm high
Circ 20-1965

75. *Kernoo*, furnishing fabric, screen-printed cotton
Designed by Victor Vasareley (1908–97) for Edinburgh
Weavers Ltd, Carlisle, 1962
Repeat 63 x 61.5cm
Circ 327-1963

76. *Chains*, woven tapestry, wool with a cotton warp
Designed by Archie Brennan for the Edinburgh Tapestry
Company Ltd (Dovecot Studios), 1974–5; the theme of chains –
used in a series of works by the artist-craftsman – was inspired
by the photograph of Isambard Kingdom Brunel standing
before the launching chains of the *Great Eastern* (Robert
Howlett, 1857)
153 x 109cm
T 187-1979

77. *Daisy Chain*, design for printed cotton, ink and
gouache on paper
Designed by Pat Albeck in 1964; produced by Cavendish
Textiles Ltd, London, for John Lewis & Co. Ltd from 17
December 1965 to 28 January 1989
Repeat 30 x 30cm, eighteen colourways
E 851-1979

78. *Jupiter*, furnishing fabric, screen-printed cotton
Designed by Isabel M. Colquhoun for Simpson and Godlee
Ltd, Manchester, 1966
Repeat 75cm high
Circ 275-1967

79. *Prince of Quince*, furnishing fabric, screen-printed
linen union
Designed by Juliet Glyn-Smith for Conran Fabrics Ltd,
London, 1965; inspired by the V&A's collection of
17th-century English embroidery
Repeat 52 x 41cm, three colourways
Circ 71-1967

80. *Verdure*, furnishing fabric, screen-printed cotton
Designed by Peter Hall for Heal Fabrics Ltd, London, 1965
Repeat 47 x 59.5cm, five colourways
Circ 257-1967

81. *Quarto*, furnishing fabric, screen-printed cotton satin
Designed by Margaret Cannon for Hull Traders Ltd, Trawden,
1969
Repeat 60.5cm high
T 128-1989

82. *Indian Summer*, furnishing fabric, screen-printed
cotton crêpe
Designed by Jyoti Bhomik for Heal Fabrics Ltd, London, 1966
Repeat 42 x 30cm, six colourways
Circ 261-1967

83. *Petrus*, furnishing fabric, screen-printed cotton crêpe
Designed by Peter Hall for Heal Fabrics Ltd, London, 1967
Repeat 63.5cm high, five colourways
Circ 28-1968

84. *Tivoli*, furnishing fabric, screen-printed cotton
Designed by Peter Hall for Heal Fabrics Ltd, London, 1967
Repeat 47 x 60cm, six colourways
Circ 27-1968

85. *Rosamund*, furnishing fabric, screen-printed cotton
Designed by Peter Hall for Heal Fabrics Ltd, London, 1975
Repeat 111.5cm high
T 726-1997

86. *Minar*, furnishing fabric, screen-printed cotton
Designed by Shelagh Wakely for Fedelis Furnishing Fabrics
Ltd, 1966
Repeat 25 x 39.5cm
Circ 5-1967

87. *Volution*, furnishing fabric, screen-printed cotton satin
Designed by Peter Hall for Heal Fabrics Ltd, London, 1969
Repeat 44cm high
Circ 40-1969

88. *Archway*, furnishing fabric, screen-printed cotton
Designed by Eddie Squires for Warner & Sons Ltd, London,
1968; produced for the 'Stereoscopic' range based on
opticians' colour-blind charts and three-dimensional effects
Repeat 65 x 30cm, four colourways
Circ 44-1969

89. *Arcade*, furnishing fabric, screen-printed cotton
Designed by Janet Taylor for Heal Fabrics Ltd, London,
1969; inspired by the Odeon style of architecture of
the inter-war years
Repeat 96.5cm high, four colourways
Circ 30-1969

90. *Complex*, furnishing fabric, screen-printed cotton satin
Designed by Barbara Brown for Heal Fabrics Ltd, London,
1967; won a Council of Industrial Design Award in 1968
Repeat 40 x 41cm, four colourways
Circ 31-1968

91. *Metropolis*, furnishing fabric, screen-printed cotton
Designed by David Bartle for Textra Furnishing Fabrics Ltd,
London, 1973
Repeat 74 x 30cm, four colourways
Circ 355-1973

92. *Extension*, furnishing fabric, screen-printed cotton
Designed by Haydon Williams for Heal Fabrics Ltd, London,
1967; won a Council of Industrial Design Award in 1968
Repeat 75cm high, six colourways
Circ 30-1968

93. *Lariat*, furnishing fabric, screen-printed cotton
Designed by Hamdi El Attar for Heal Fabrics Ltd, London,
1969
Repeat 80.5cm high, four colourways
Circ 36-1969

94. *Perimeter*, furnishing fabric, screen-printed cotton
Designed by Anne Fehlow for Heal Fabrics Ltd, London, 1969
Repeat 62.5 x 30.5cm, four colourways
Circ 782-1969

95. *Ikebana*, furnishing fabric, screen-printed cotton satin
Designed by Barbara Brown for Heal Fabrics Ltd, London,
1970
Repeat 73cm high
Circ 141-1976

96. *Space Walk*, furnishing fabric, screen-printed cotton
Designed by Sue Palmer for the 'Centenary' collection
produced by Warner & Sons Ltd, London, 1969; created to
commemorate the moon landing in July 1969
Repeat 44.5 x 119cm, one colourway
Circ 44-1970

97. *Lunar Rocket*, furnishing fabric, screen-printed cotton
Designed by Eddie Squires for the 'Centenary' collection
produced by Warner & Sons Ltd, London, 1969; created to
commemorate the moon landing in July 1969
Repeat 64 x 74cm, one colourway
Circ 45-1970

98. *Raspberry Lips*, furnishing fabric, screen-printed synthetic
ground with satin finish
Designed by Jane Wealleans and produced by OK Textiles Ltd,
London, 1973
Repeat 7.5 x 9cm
Circ 172-1973

99. *Lipstick*, sample of dress fabric, screen-printed silk crêpe
Designed by Zandra Rhodes, 1968; influenced by Guy
Bourdin's magazine advertisement for Christian Dior
cosmetics, 'Les sables pastels'
87.5 x 76cm
Circ 266-1974

100. *Cakes*, furnishing fabric, screen-printed synthetic ground
with satin finish
Designed by Jane Wealleans for OK Textiles Ltd, London, 1973
Repeat 25 x 15cm
Circ 171-1973

101. *Soup Can*, dress fabric, screen-printed silk
Designed by Lloyd Johnson for Patrick Lloyd Ltd,
London, 1973
Repeat 20 x 6.5cm
Circ 302-1973

102. *Salad Days*, furnishing fabric, screen-printed cotton
Designed by Kay Politowicz for Textra Furnishing Fabrics Ltd,
London, 1973
Repeat 62cm high, one colourway
Circ 350-1973

103. *Marilyn*, dress fabric, screen-printed synthetic ground
with crêpe finish
Designed by Christopher Snow and produced by Slick Brands
(Clothing) Ltd, London, 1974; derived from photographic
images of Marilyn Monroe taken from magazines and
film stills
Repeat 155 x 91cm
Circ 450-1974

104. *Legs*, furnishing fabric, screen-printed synthetic ground
with satin finish
Designed by Jane Wealleans for OK Textiles Ltd, London, 1973
Repeat 15 x 15.5cm
Circ 169-1973

105. *Fred*, furnishing fabric, screen-printed silk
Designed by Lloyd Johnson and produced by Patrick Lloyd,
London, 1973
Repeat 24 x 8.5cm
Circ 303-1973

106. *Button Flower*, sample of dress fabric, screen-printed
silk chiffon
Designed by Zandra Rhodes, 1971; inspired by floral
and geometric-shaped buttons purchased from
J. J. Stern Ltd, London
48 x 113cm
Circ 263-1974

107. *Camelia*, furnishing fabric, screen-printed cotton
Designed by Mary Oliver for Heal Fabrics Ltd, London, 1975
Repeat 73 x 61cm
T 752-1997

108. *Graphic Two*, furnishing fabric, screen-printed cotton
Designed by the Ryman-Conran Studio for Conran Fabrics Ltd,
London, 1970
Repeat 23.5 x 23.5cm
Circ 93-1971

109. *Graphic Four*, furnishing fabric, screen-printed cotton
Designed by the Ryman-Conran Studio for Conran Fabrics Ltd,
London, 1970
Repeat 25.5 x 40cm
Circ 95-1971

110. *Clandon*, furnishing fabric, roller-printed cotton
Designed by Susan Collier and Sarah Campbell for Liberty of
London Prints Ltd, 1977
Repeat 30 x 58cm, three colourways
T 43-1978

111. *Cottage Garden*, furnishing fabric, roller-printed cotton
First issued in 1974–5; designed by Susan Collier and Sarah
Campbell for Liberty of London Prints Ltd, 1977
Repeat 51 x 79.5cm, three colourways
T 44-1978

112. *Geranium*, furnishing fabric, screen-printed cotton
Designed and produced by Designers Guild Ltd, London, 1976
Repeat 40 x 41cm
T 69-1978

113. *Square Spectrum Spiral*, hanging, interlaced woollen
knitted tubes
Ann Sutton, 1973
196 x 196cm
T 76-1982

114. Rag rug, double-corduroy woven with dyed calico and
mercerized cotton poplin
John Hinchcliffe, 1978
264 x 198cm
T 161-1978

115. *Côte D'Azure*, furnishing fabric, screen-printed cotton
Designed by Susan Collier and Sarah Campbell and produced
under licence by Fischbacher Ltd, 1983; inspired by the work
of Henri Matisse; issued as part of the '6 Views' collection
which won a Design Council Award in 1984
Repeat 90cm high, four colourways
T 187-1984

116. *Havana*, furnishing fabric, screen-printed cotton
Designed by Susan Collier and Sarah Campbell and
produced under licence by Fischbacher Ltd, 1983; issued as
part of the '6 Views' collection which won a Design Council
Award in 1984
Repeat 63.5 x 67.5cm, four colourways
T 185-1984

117. *Aquarelle*, furnishing fabric, screen-printed glazed cotton
Designed by Sue Palmer for the 'Designers Choice I'
collection produced by Warner & Sons Ltd, London, 1985;
inspired by the designer's swimming pool in the Bahamas
Repeat 64 x 68.5cm, four colourways
T 145-1987

118. *London Tassels*, furnishing fabric, screen-printed
glazed cotton
Designed by Mandy Martin for the 'Designers Choice III'
collection produced by Warner Fabrics plc, Milton Keynes,
1987–8; designed to go with wallpaper and border paper
London Stripe
Repeat 46 x 33cm, four colourways
T 42-1990

119. *Panache*, furnishing fabric, screen-printed glazed cotton
Designed by Anne White for the 'Designers Choice' collection
produced by Warner & Sons Ltd, London, 1985
Repeat 81 x 69cm, six colourways
T 148-1987

120. *Gaudi*, sample of dress fabric, screen-printed and
discharge-dyed silk
Designed by Helen Littman for English Eccentrics, London,
1984; inspired by parts of the mosaic wall created by the
architect Antoni Gaudí in Parque Güell, Barcelona; the design
was adapted for use as furnishing fabric in 1987
91.5 x 85cm, four colourways
T 299-1988

121. *Fallen Angel*, furnishing fabric, screen-printed cotton satin
Designed and printed by Timney Fowler Ltd, London, 1986;
forms part of the 'Neo Classical' collection
Repeat 69.5cm high
T 201-1989

122. *Columns*, furnishing fabric, screen-printed cotton satin
Designed and printed by Timney Fowler Ltd, London, 1983;
forms part of the 'Neo Classical' collection
Repeat 88 x 13cm
T 207-1989

123. *Composite* or *Collage*, furnishing fabric, discharge-printed
cotton velvet
Designed and printed by Timney Fowler Ltd, London, 1987;
produced for the 'Noir' collection
Repeat 146cm high
T 205-1989

124. Dress fabric, screen-printed wool
Designed and printed by The Cloth, London, 1985
Repeat 149 x 139cm, two colourways
T 200-1987

125. Dress fabric, screen-printed wool
Designed and printed by The Cloth, London, 1985
92 x 112cm, two colourways
T 199-1987

126. *Hands*, dress fabric, screen-printed and discharge-dyed silk
Designed by Helen Littman for English Eccentrics, London,
1984; inspired by the designer's first trip to New York where
she was influenced by grafitti, palmistry parlour imagery and
the work of street artist Keith Haring. One of English
Eccentrics' most well known designs.
Repeat 58.5 cm high, five colourways
T 297-1988

127. *Water*, furnishing fabric, screen-printed glazed cotton
Designed by Howard Hodgkin (b. 1932) for Warner & Sons Ltd,
London, 1983; created for the Arts Council exhibition *Four
Rooms* which opened at Liberty's in February 1984
Repeat 91 x 33cm, three colourways
T 233A-1984

128. *Autograph*, furnishing fabric, screen-printed glazed cotton
Designed by Howard Hodgkin (b. 1932) for Warner & Sons Ltd,
London, 1983; created for the Arts Council exhibition *Four
Rooms* which opened at Liberty's in February 1984
Repeat 45 x 30cm, three colourways
T 232-1984

129. Detail of hanging, ikat silk
Mary Restieaux, 1980
146 x 41.5cm
T 432-1980

130. Hanging, quilted and spray-dyed acetate satin
Diana Harrison, 1985
88 x 115cm
T 151-1985

131. *Release*, wall panel of batik-dyed cotton
Noel Dyrenforth, 1981
122 x 94cm
T 89-1989

132. Banner, painted wool
Sian Tucker, 1986
200 x 138cm
T 133-1986

133. Screen-printed and dyed silk satin
Victoria Richards, 1989
232 x 111cm
T 258-1989

134. Detail of hanging, screen-printed and painted silk
Neil Bottle, 1990
251 x 98cm
T 272-1991

135. *TOW 873*, banner, painted spun silk
Sally Greaves-Lord, 1988
434 x 91cm
T 122-1988

136. *Grand Acanthus*, furnishing fabric, screen-printed cotton
Designed by Paul Simmons for the 'Architextural' range
produced by Warner Fabrics plc, Milton Keynes, 1993
Repeat 64 x 65cm, three colourways
T 166-1993

137. *Large Eel*, furnishing fabric, screen-printed cotton velvet
Designed by Paul Simmons for Timorous Beasties,
Glasgow, 1992
Repeat 154cm high
T 422-1992

138. *May Tree*, furnishing fabric, screen-printed cotton
Designed by Michael Heindorff (b. 1949) for the 'Still Life'
collection produced by Designers Guild Ltd, London, 1992
Repeat 62 x 77cm, three colourways
T 425:1-1992

139. *Tracer*, sample of furnishing fabric, screen-printed cotton
Designed by Michael Heindorff (b. 1949) for the 'Still Life'
collection produced by Designers Guild Ltd, London, 1992
65 x 66cm, three colourways
T 428:3-1992

140. *Pin Stripe*, sample of dress fabric, heat-photogram printed
microfibres
Rebecca Earley, 1995
74.5 x 38cm

T 123-1997

141. *Scattered Pins*, sample of dress fabric, heat-photogram printed microfibres
Rebecca Earley, 1995; commissioned by the singer Bjork and used as the designer's signature B. Earley label
59 x 44.5cm
T 126-1997

142. *Girl with Amoebas*, sample of dress fabric, screen-printed and decorated crêpe-de-chine
Luiven Rivas-Sanchez, 1987; chosen to represent the UK in the Third International Fashion Foundation of Japan competition in 1987
60 x 113cm
T 471-1992

143. Sample of dress fabric, screen-printed and decorated crêpe-de-chine
Luiven Rivas-Sanchez, 1990
45 x 55cm
T 474-1992

144. Sample of dress fabric, screen-printed and heat-treated silk/viscose velvet, *Edelweiss Smocking*
Nigel Atkinson for Romeo Gigli, Autumn/Winter 1990
Repeat 7 x 6.5cm
T 530-1994

145. *Sea Anemone*, sample of dress fabric, screen-printed and heat-treated silk
Nigel Atkinson, 1989
31 x 19cm
T 527-1994

146. *Tigermoon*, detail of scarf, silk/viscose devoré
Designed by Neisha Crosland, London, 1996; produced by Belford Prints, Macclesfield
191 x 27cm, five colourways
T 495-1997

147. *Checkered Flower*, detail of scarf, screen-printed and heat-treated silk organza woven with metal threads
Designed by Neisha Crosland, London, Autumn/Winter 1997; produced by Belford Prints, Macclesfield
162 x 54cm, three colourways
T 493-1997

148. *Shrine*, hanging, painted spun silk
Carole Waller, 1996; inspired by the artist's travels in South America
233 x 116cm
T 121-1997

149. Hanging, silk/viscose velvet devoré
Sharon Ting, 1997
234 x 54cm
T 168-1997

150. *Peeling Paint*, hanging, wool devoré
Gilian Little, 1996
172 x 87cm
T 147-1997

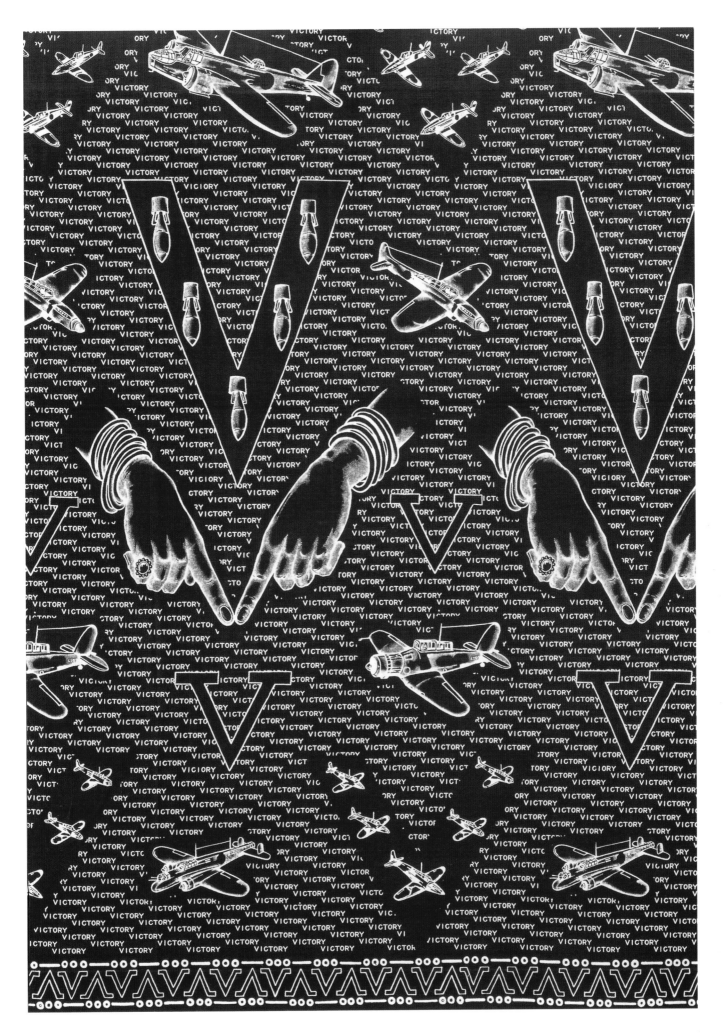

1. *Victory V*, printed cotton, produced by the Calico Printers' Association, 1941. Circ 510-1974.

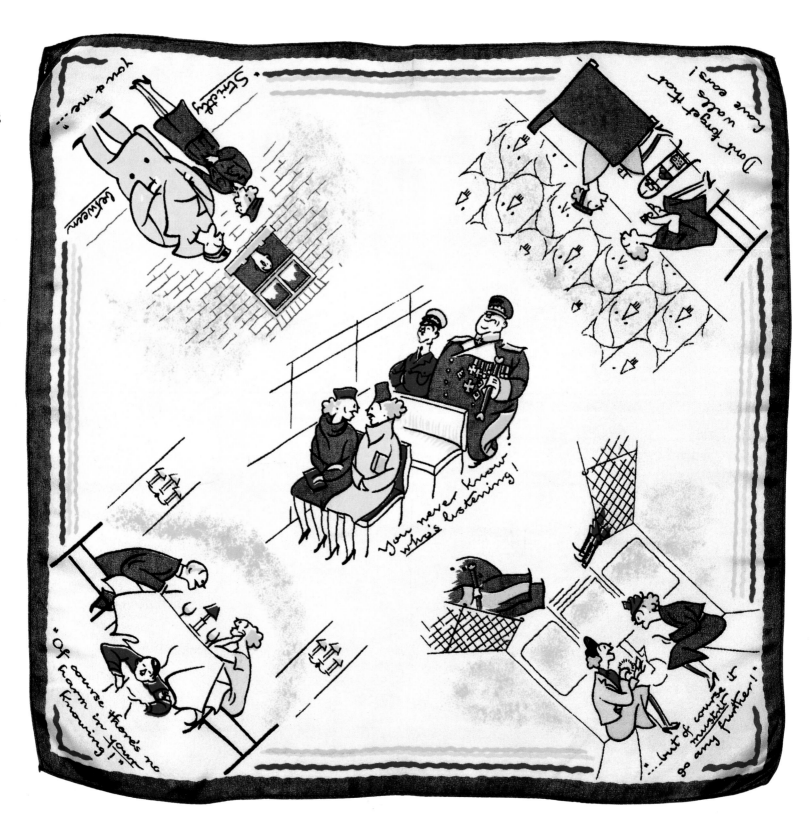

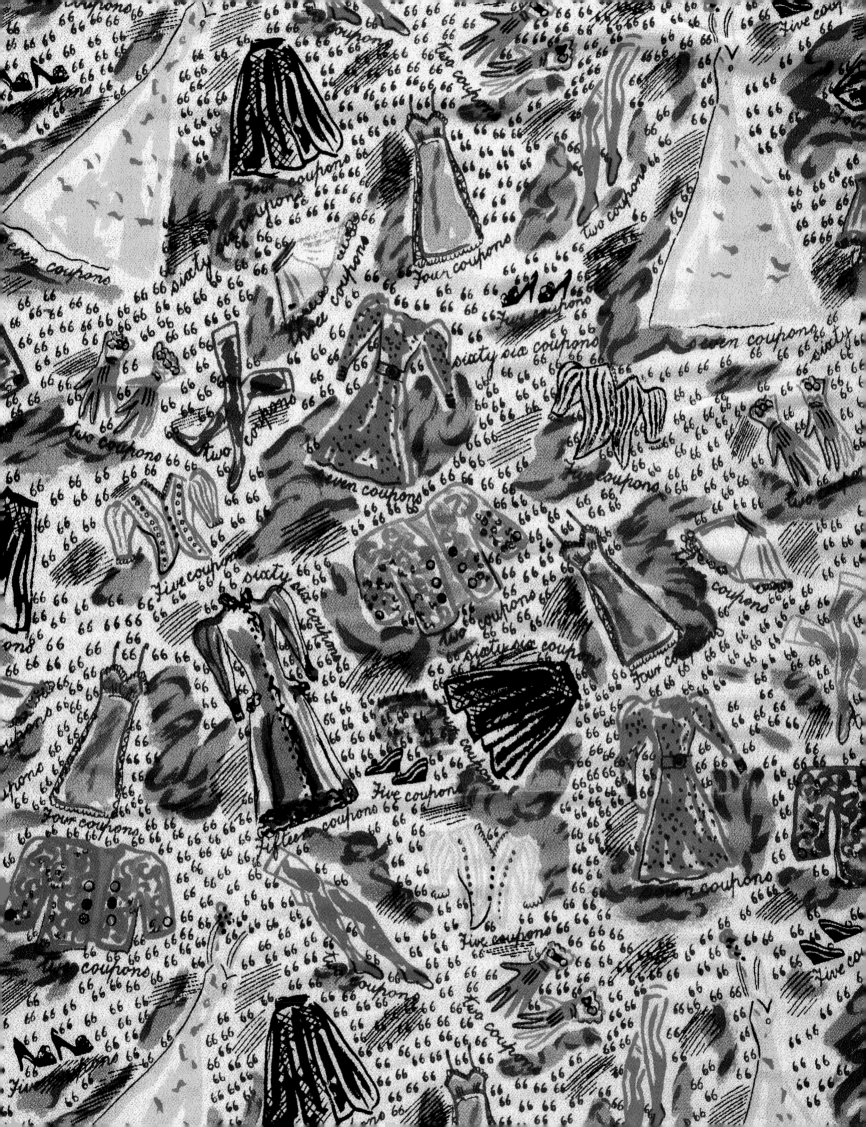

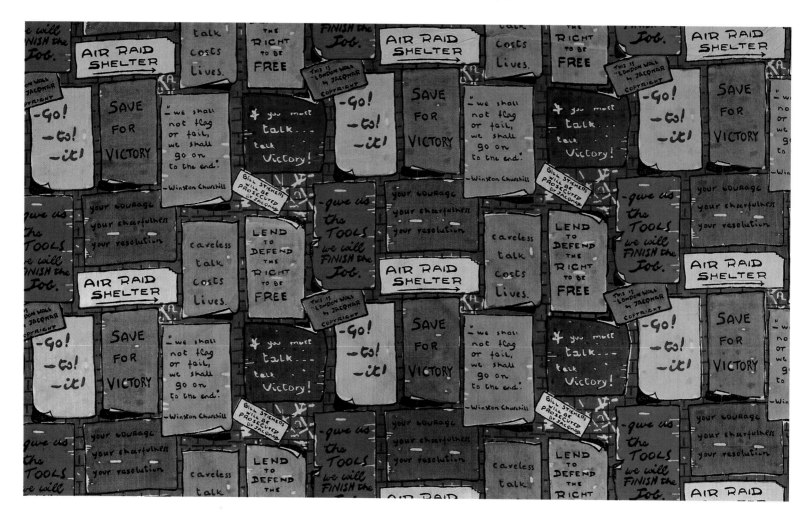

40

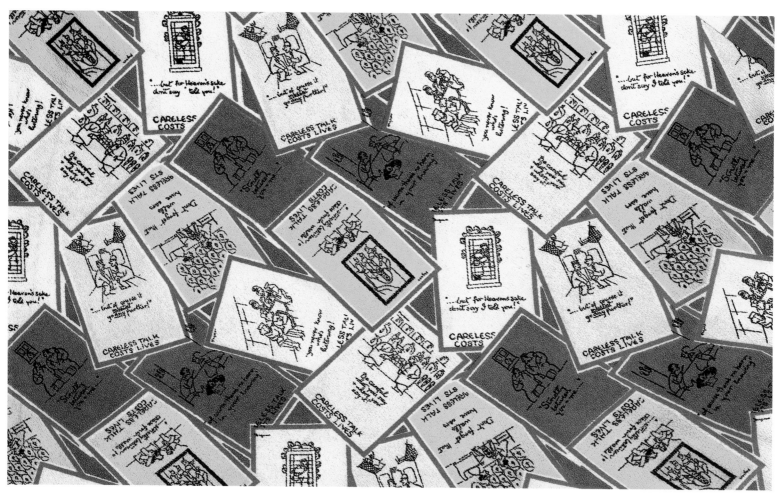

5. *Careless Talk Costs Lives*, printed rayon crêpe, c. 1943. Circ 74-1975.

6. *Ring*, woven cotton, designed by Enid Marx for the Board of Trade Utility Design Panel, 1945. Circ 217-1949.

7. *Honeycomb*, woven cotton, designed by Enid Marx for the Board of Trade Utility Design Panel, 1947. Circ 215-1949.

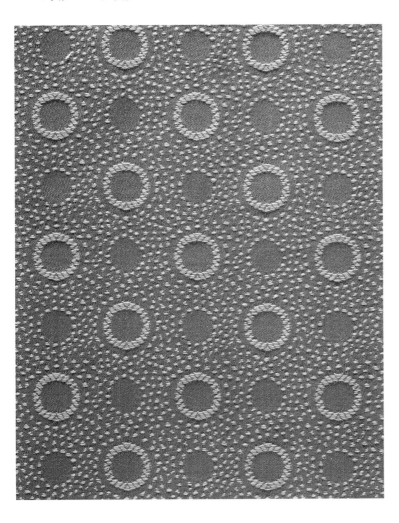

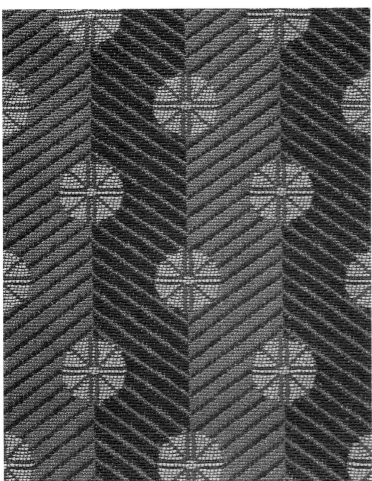

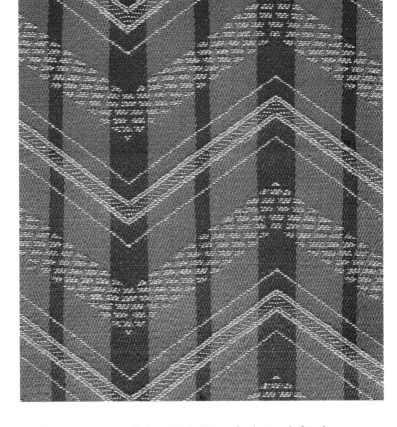

8. *Spot and Stripe*, woven cotton, designed by Enid Marx for the Board of Trade Utility Design Panel, 1945. Circ 221F-1949.

9. *Chevron*, woven cotton, designed by Enid Marx for the Board of Trade Utility Design Panel, 1946. Circ 203A-1949.

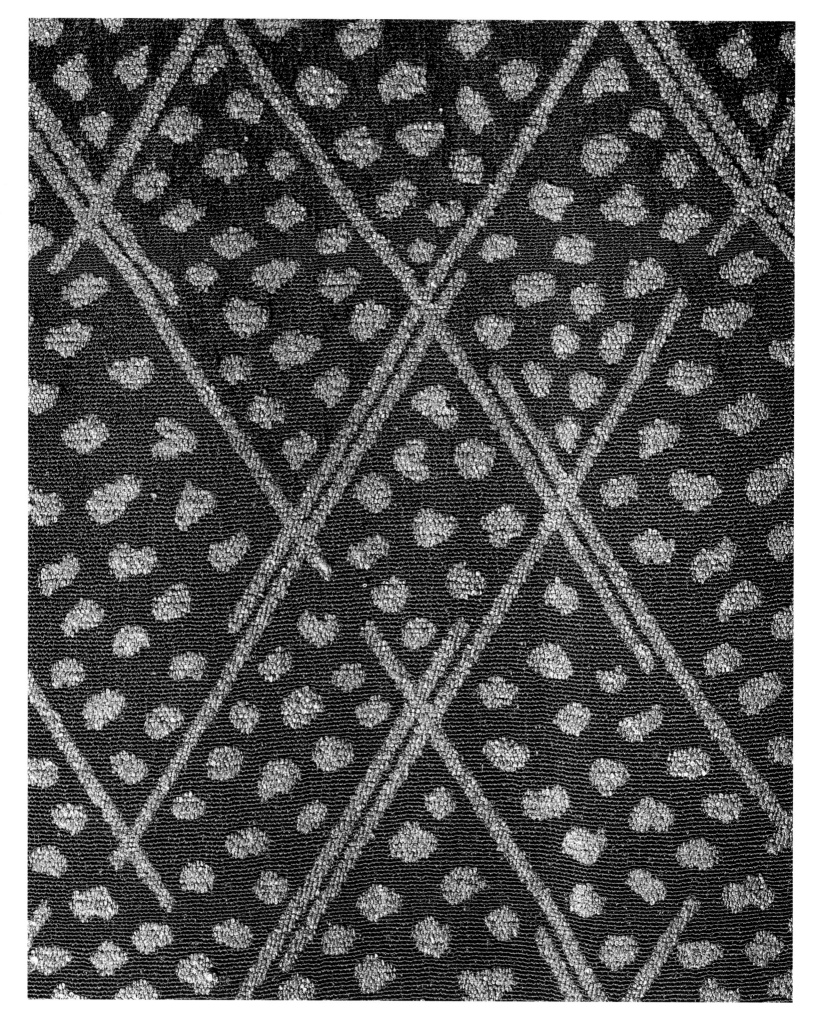

10. *Totley*, dobby woven rayon, designed by Marianne Straub for Helios Ltd, 1947.
Circ 77-1947.

11. Screen-printed rayon samples, designed by Eric Stapler for Ascher Ltd, 1945. T 137C-1988.

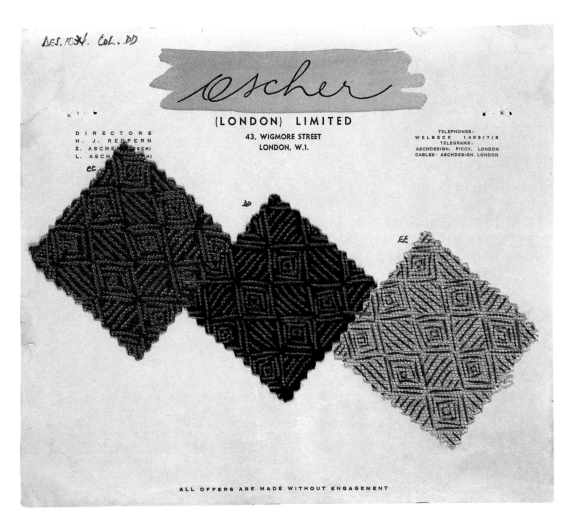

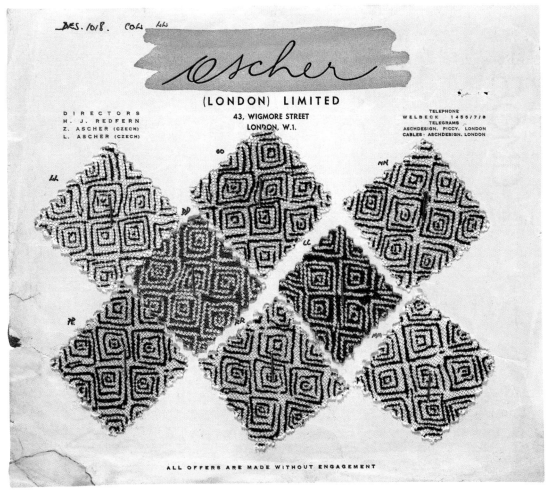

12. Screen-printed rayon samples, designed by Eric Stapler for Ascher Ltd, 1945. T 137D-1988.

13. *Web*, screen-printed rayon crêpe, designed by Graham Sutherland for Cresta Silks Ltd, 1947. Circ 105-1947.

14. Screen-printed spun rayon, designed by Julian Trevelyan for Ascher Ltd, 1946. Circ 95B-1947.

15. *Aztec*, screen-printed rayon, designed by Patrick Heron for Cresta Silks Ltd, 1947. Circ 106E-1947. © Patrick Heron 1998. All rights reserved DACS.

16. *Piano* or *Keyboard*, screen-printed rayon, designed by
Henry Moore for Ascher Ltd, 1948. T 94-1992.

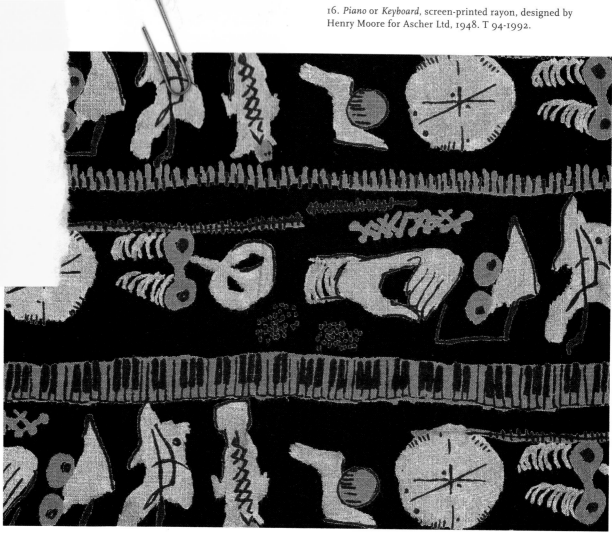

17. Screen-printed rayon, designed by Henry Moore for Ascher Ltd,
c. 1945. T 402A-1980.

18. *Wigwam*, screen-printed spun rayon, designed by Mary Duncan for Cresta Silks Ltd, 1947. Circ 107-1947.

19. *Jungle*, screen-printed spun rayon, designed by Feliks Topolski for Ascher Ltd, *c.* 1946. Circ 418-1948.

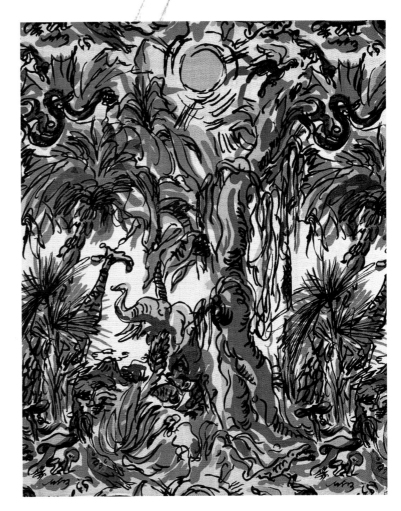

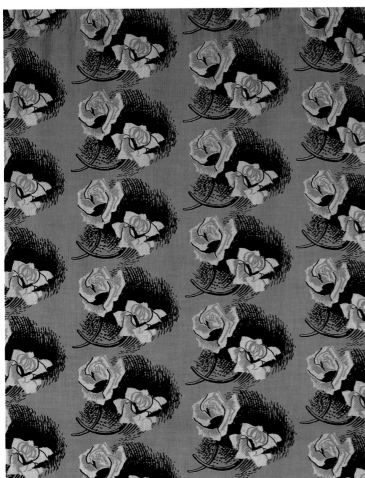

20. *Sutherland Rose*, screen-printed cotton, designed by Graham Sutherland, manufactured by Helios Ltd, 1946. Circ 71-1947.

21. *Festival of Britain*, screen-printed rayon satin, designed by John Barker for David Whitehead Ltd, 1951. T 288-1982.

48

22. *Plankton*, screen-printed cotton, designed by Gerald Holtom for Gerald Holtom Ltd, 1951. Circ 225-1951.

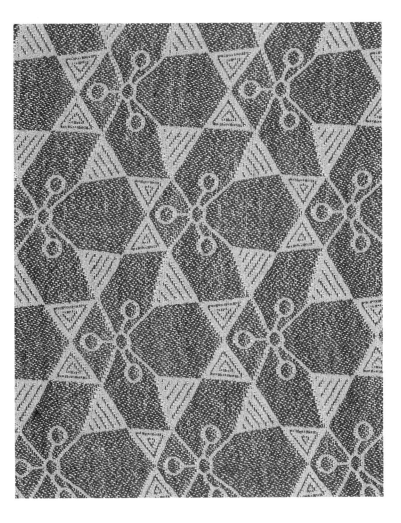

23. *Orthoclase*, woven linen, produced by the Old Bleach Linen Company, 1951. Circ 65-1952.

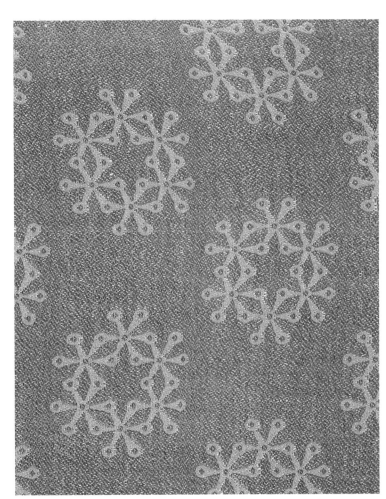

24. *Hydrargillite*, woven linen, produced by the Old Bleach Linen Company, 1951. Circ 64-1952.

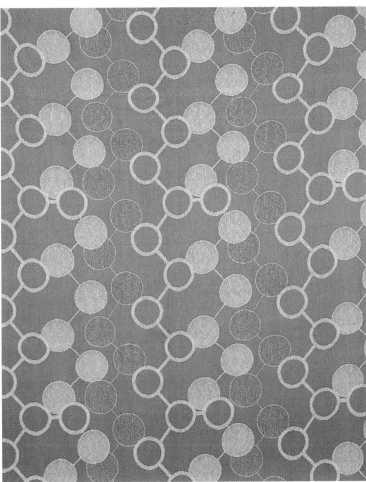

25. *Helmsley*, jacquard woven cotton, designed by Marianne Straub for Warner & Sons Ltd, 1951. Circ 308-1951.

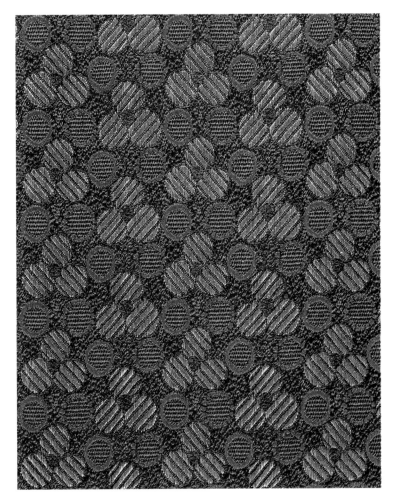

26. *Chalk*, woven silk, designed by Bernard Rowland for Vanners & Fennell Ltd, 1951. T 446F-1977.

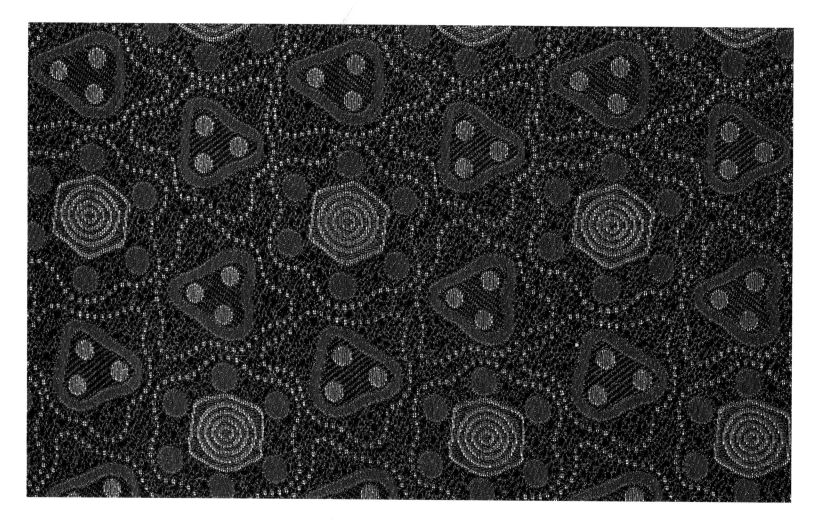

50

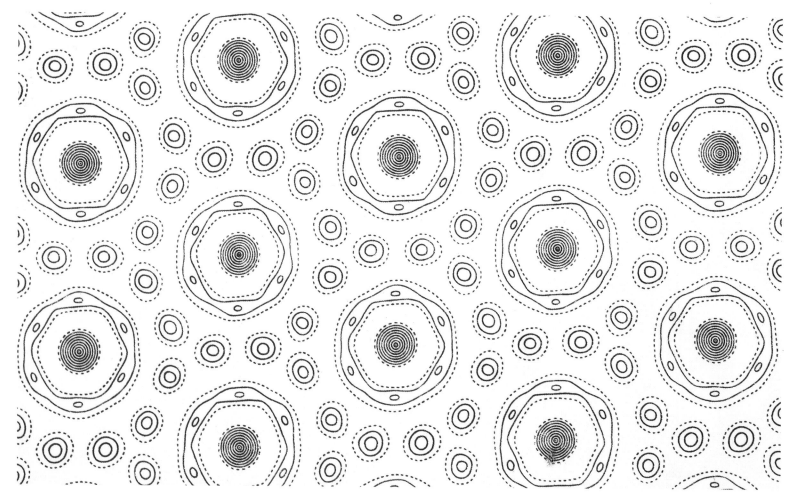

28. *Haemoglobin*, screen-printed cotton, produced by Barlow & Jones Ltd, 1951. Circ 77-1968.

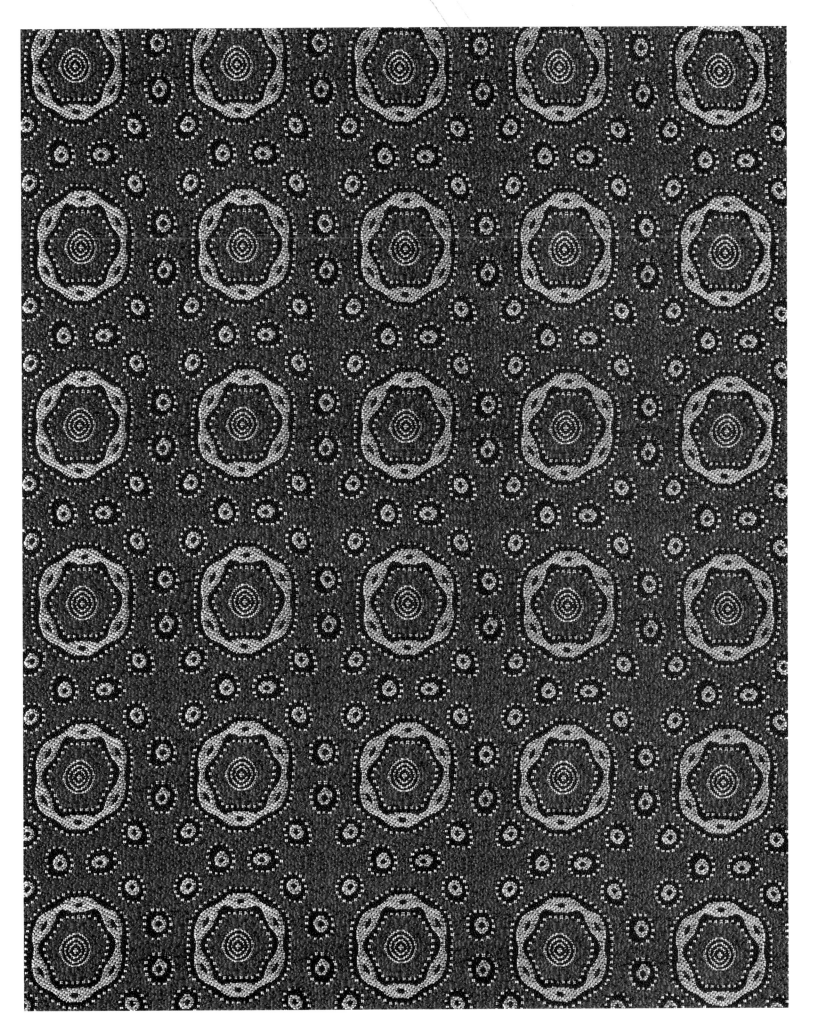

29. *Haemoglobin*, woven silk, designed by Bernard Rowland for
Vanners & Fennell Ltd. Circ 72-1968.

53

31. *Surrey*, jacquard woven wool, cotton and rayon, designed by Marianne Straub for Warner & Sons Ltd, 1951. Circ 306-1951.

32. Screen-printed cotton crêpe, designed by Marian Mahler for
David Whitehead Ltd, 1952.Circ 8-1953.

33. Roller-printed spun rayon, designed by Jacqueline Groag for
David Whitehead Ltd, 1952. Circ 12-1953.

54

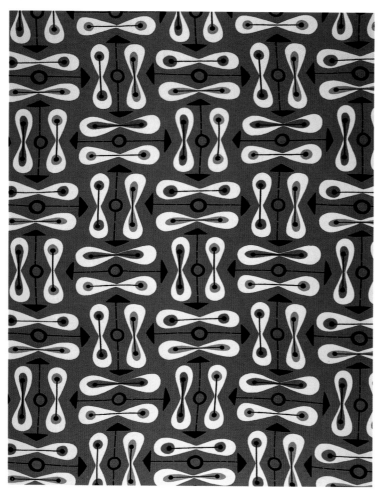

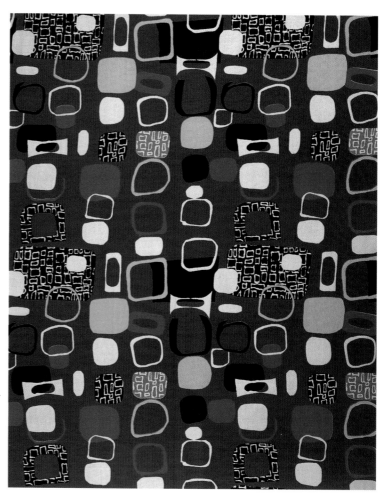

34. Roller-printed spun rayon, designed by J. Feldman for
David Whitehead Ltd, 1954. Circ 504-1954.

35. Roller-printed spun rayon, designed by Jacqueline Groag for
David Whitehead Ltd, 1952. Circ 13-1953.

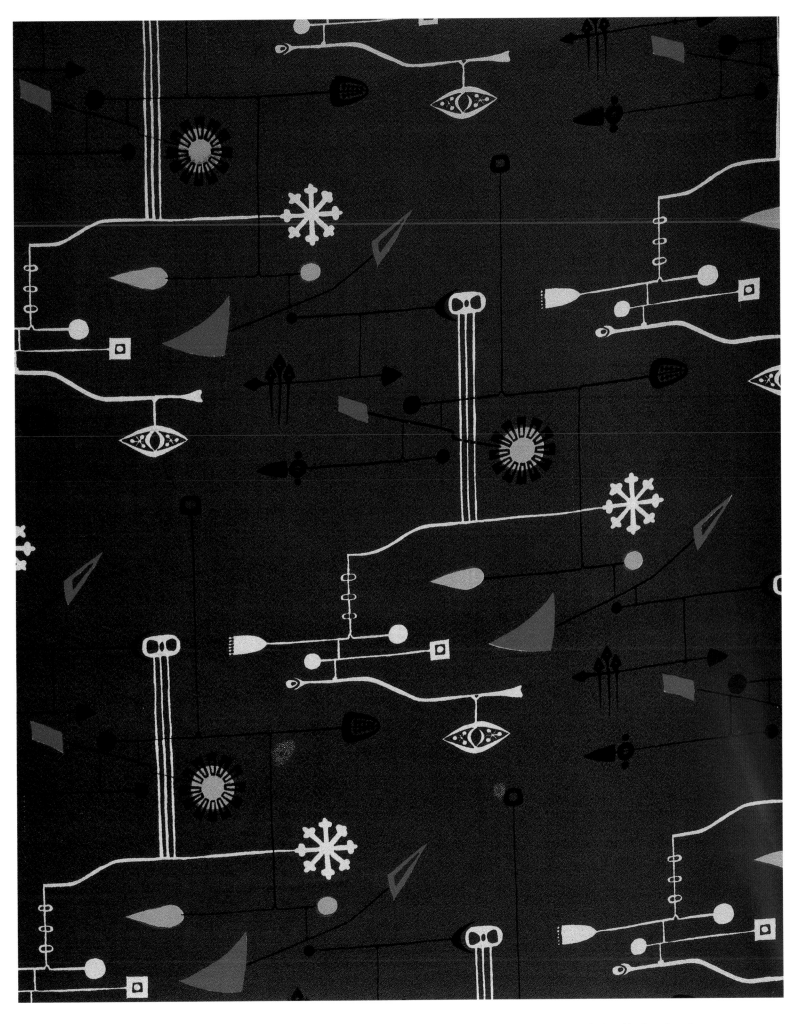

36. *Mobile*, screen-printed rayon satin, designed by June Lyon for
Heal's Wholesale & Export Ltd, 1954. Circ 208-1954.

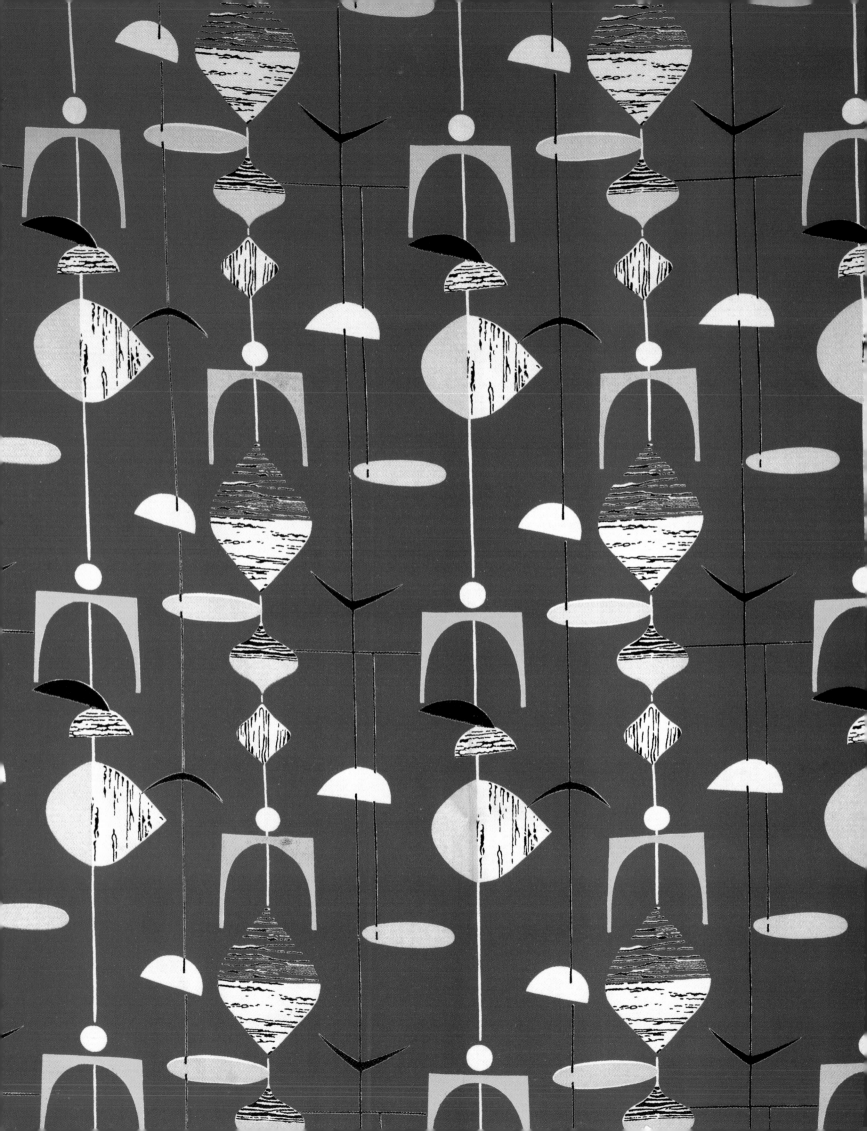

37. Screen-printed cotton crêpe, designed by Marian Mahler for David Whitehead Ltd, *c.* 1952. T 504:2-1996.

38. *Totem,* screen-printed rayon, designed by Terence Conran Gerald Holtom Ltd, 1951. Circ 226-1951.

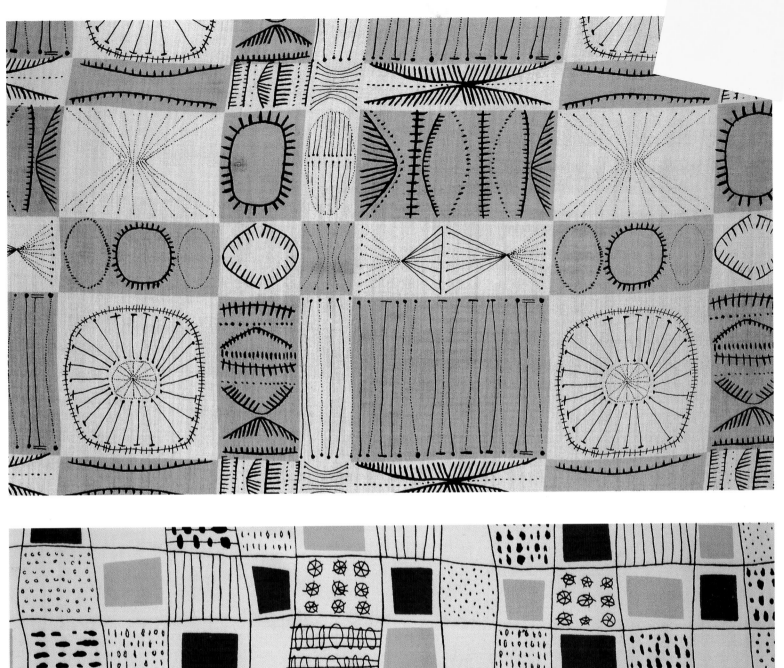

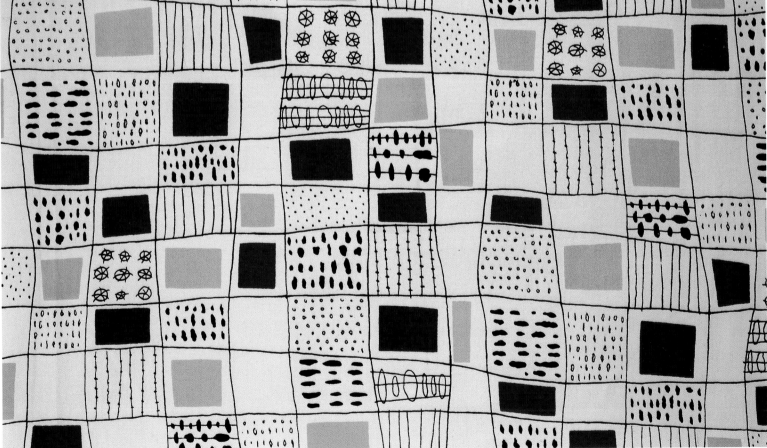

39. *Chequers,* screen-printed cotton satin, designed by Terence Conran for David Whitehead Ltd, 1951. Circ 283-1951.

58

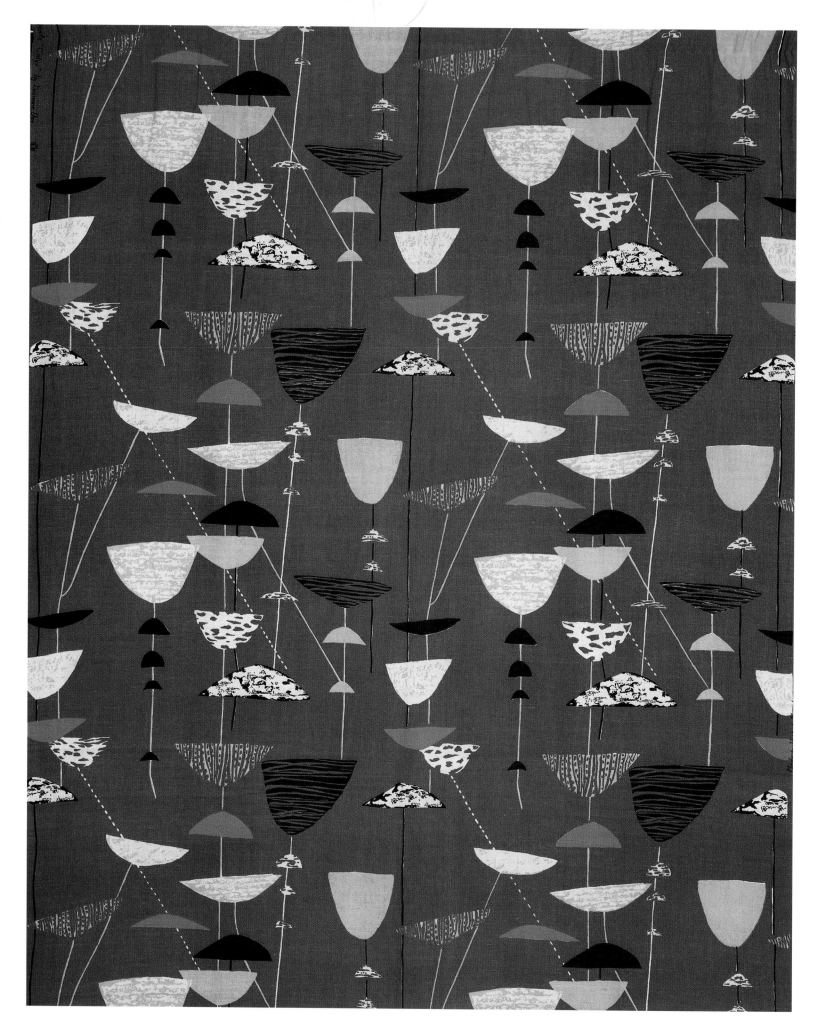

40. *Calyx*, screen-printed linen, designed by Lucienne Day for
Heal's Wholesale & Export Ltd, 1951. Circ 190-1954.

41. *Rig*, screen-printed linen, designed by Lucienne Day for Heal's Wholesale & Export Ltd, 1953. Circ 53-1953.

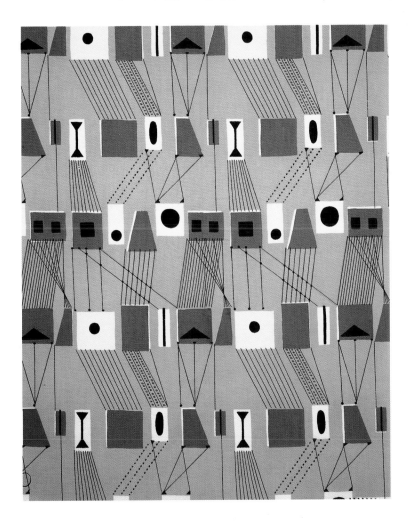

42. *Graphica*, screen-printed cotton, designed by Lucienne Day for Heal's Wholesale & Export Ltd, 1954. Circ 211-1954.

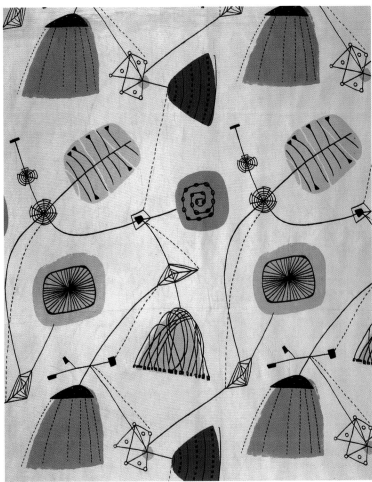

43. *Perpetua*, screen-printed rayon taffeta, designed by Lucienne Day for British Celanese Ltd, 1953. Circ 385-1953.

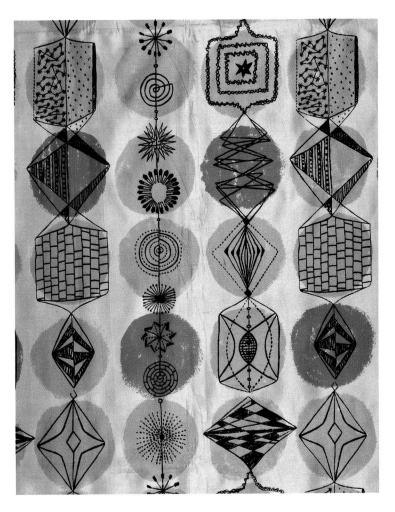

44. *Miscellany*, screen-printed rayon taffeta, designed by Lucienne Day for British Celanese Ltd, 1953. Circ 383-1954.

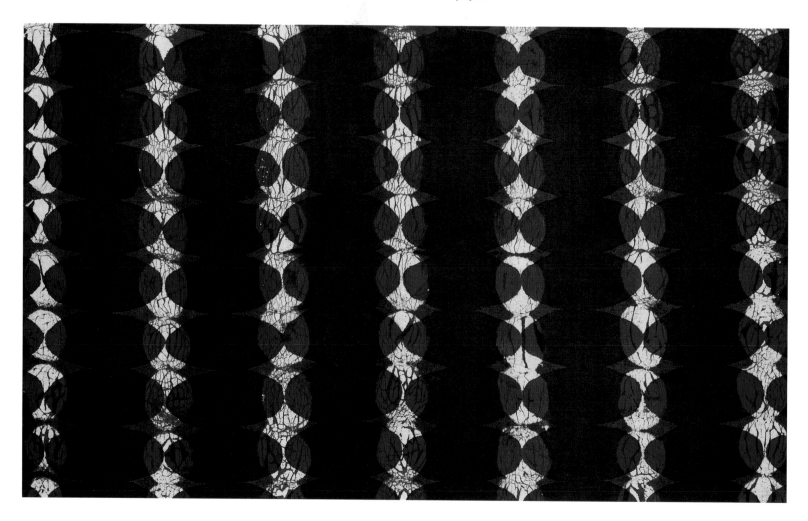

45. Block-printed and indigo resist-dyed cotton, by Susan Bosence, *c.* 1960. Circ 289-1961.

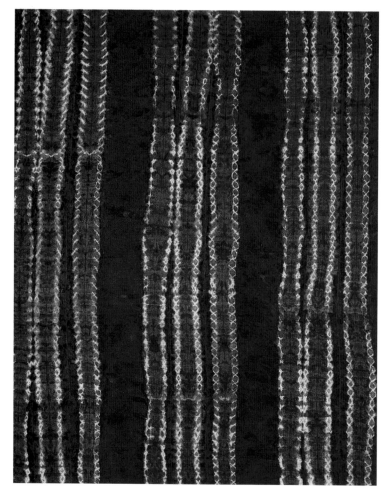

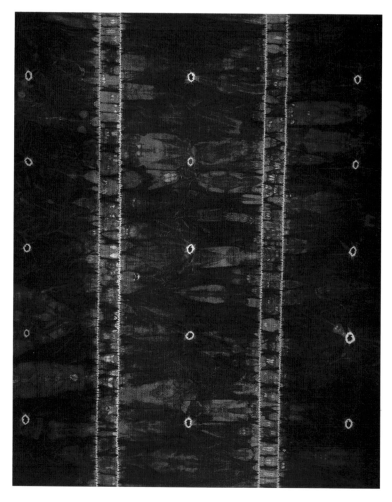

46. Indigo tie-dyed and sewn cotton, made under the direction of Susan Bosence, *c.* 1961. Circ 104-1962.

47. Indigo tie-dyed cotton, made under the direction of Susan Bosence, *c.* 1961. Circ 95-1962.

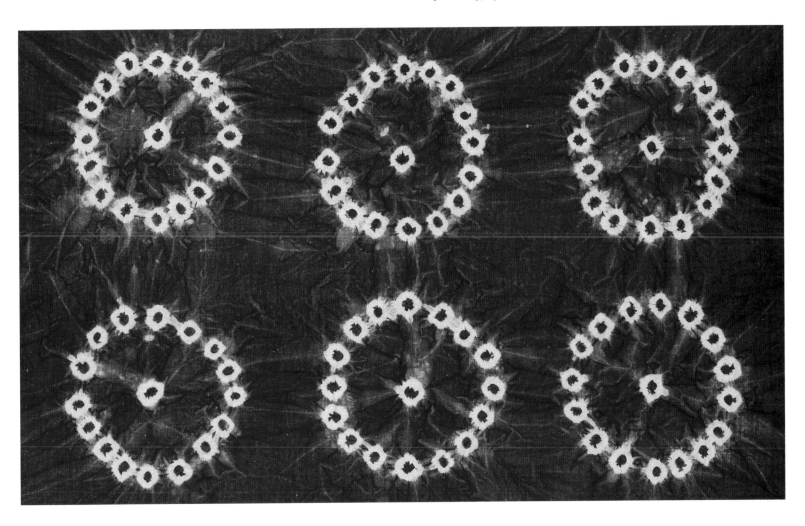

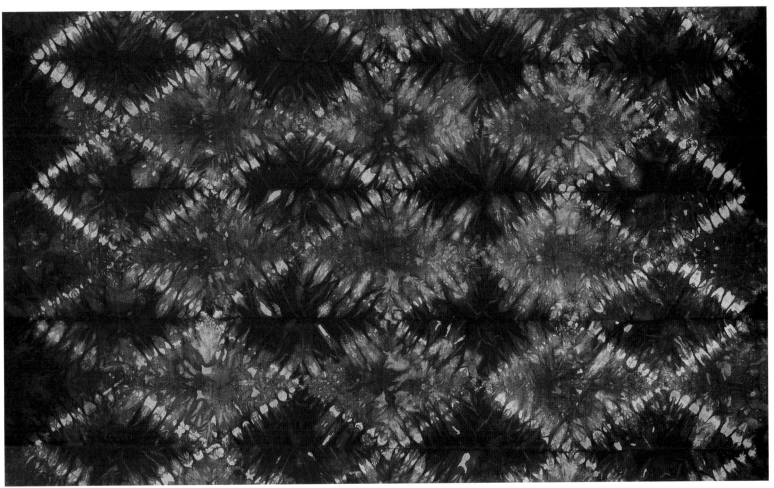

49. Indigo tie-dyed cotton, made under the direction of Susan Bosence,
c. 1961. Circ 98-1962.

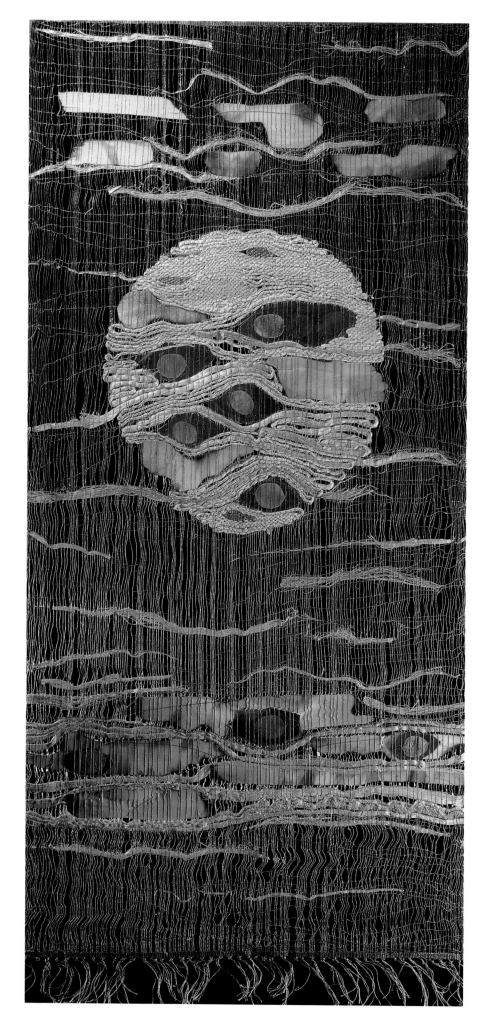

50. *Moon*, woven ramie and camel hair with inserts,
by Tadek Beutlich, *c.* 1963. Circ 1180-1967.

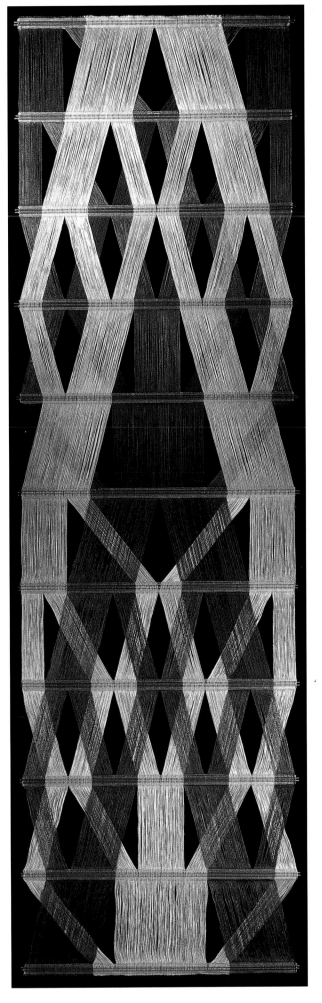

51. *Macrogauze 26*, woven black and natural linen
with stainless steel rods, by Peter Collingwood,
1968. Circ 211-1969.

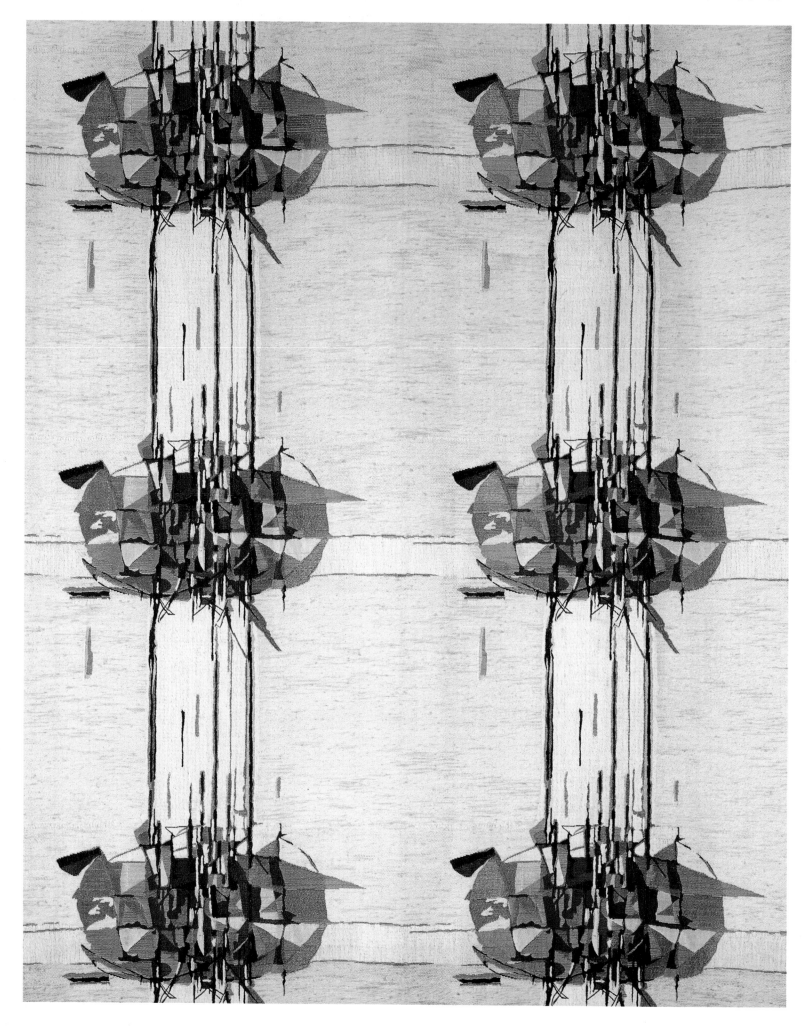

52. *Crystalline Image*, jacquard woven cotton and rayon, designed by Alan Reynolds for Edinburgh Weavers Ltd, 1962. Circ 325-1963.

54. *Northern Cathedral*, screen-printed cotton satin, designed by John Piper
for Sanderson Fabrics Ltd, 1961. Circ 586-1963.

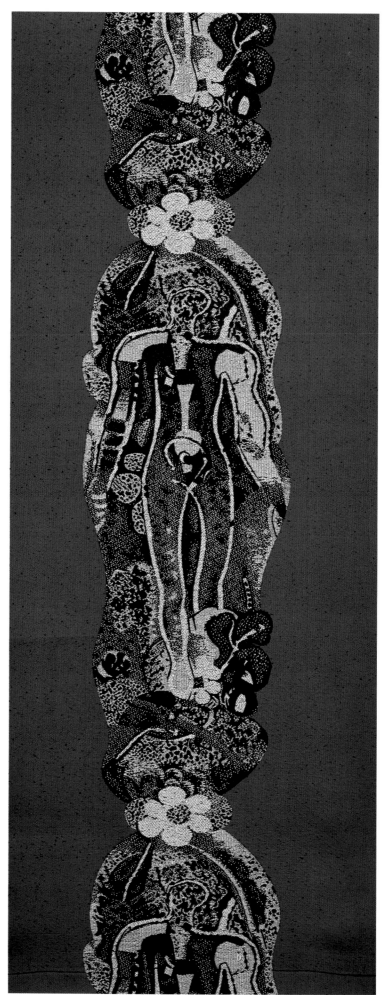

56. *Avon*, screen-printed cotton and rayon satin, designed by Cecil Collins for Edinburgh Weavers Ltd, 1960. Circ 685-1966.

57. *Adam*, jacquard woven cotton and rayon, designed by Keith Vaughan for Edinburgh Weavers Ltd, 1958. Circ 466-1963.

58. *Cavallo*, jacquard woven cotton and rayon, designed by Marino Marini for Edinburgh Weavers Ltd, 1960. Circ 295-1960.

59. *Riders*, screen-printed linen, designed by Marino Marini for Edinburgh Weavers Ltd, 1960. Circ 692-1966.

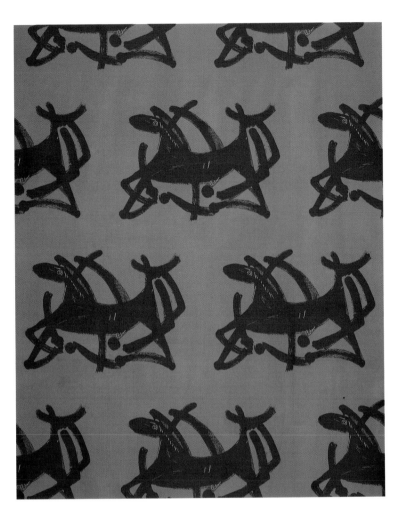

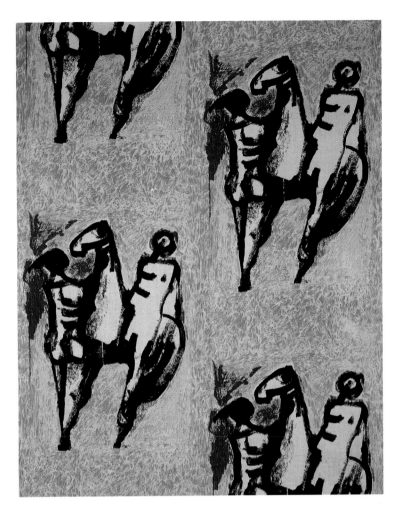

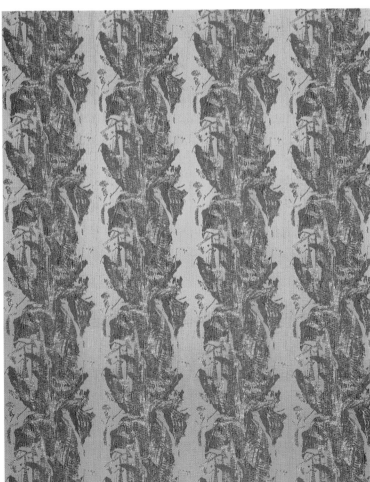

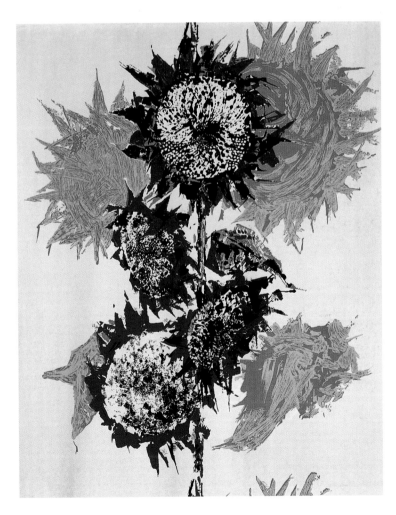

60. *Inglewood*, jacquard woven cotton and rayon, designed by Humphrey Spender for Edinburgh Weavers, 1959. Circ 465-1963.

61. *Sunflower*, screen-printed cotton crêpe, designed by Howard Carter for Heal Fabrics Ltd, 1962. Circ 598-1963.

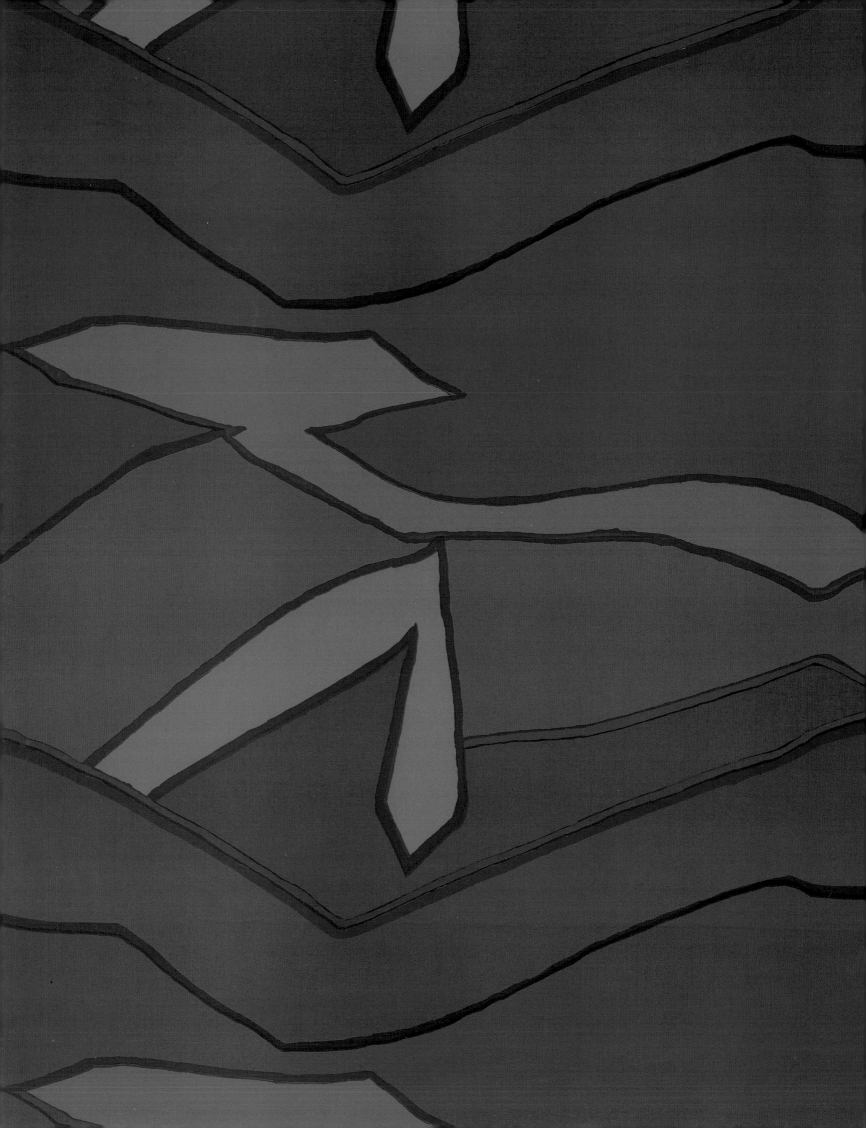

62. *Division*, screen-printed cotton satin, designed by Shirley Craven for
Hull Traders Ltd, 1964. Circ 121B-1965.

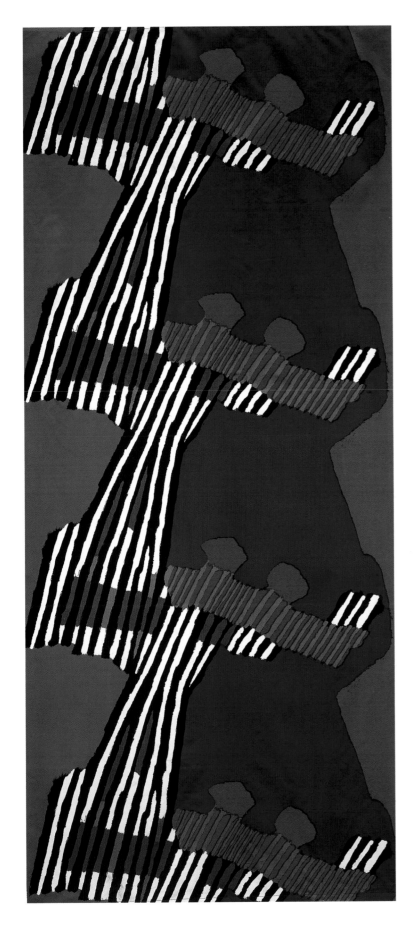

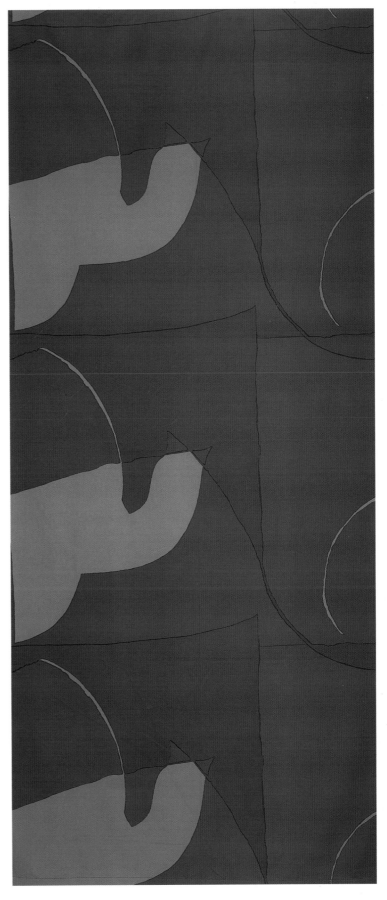

63. *Focus*, screen-printed cotton satin, designed by Doreen Dyall for
Heal Fabrics Ltd, 1965. Circ 255-1967.

64. *Shape*, screen-printed cotton satin, designed by Shirley Craven for
Hull Traders Ltd, 1964. Circ 121E-1965.

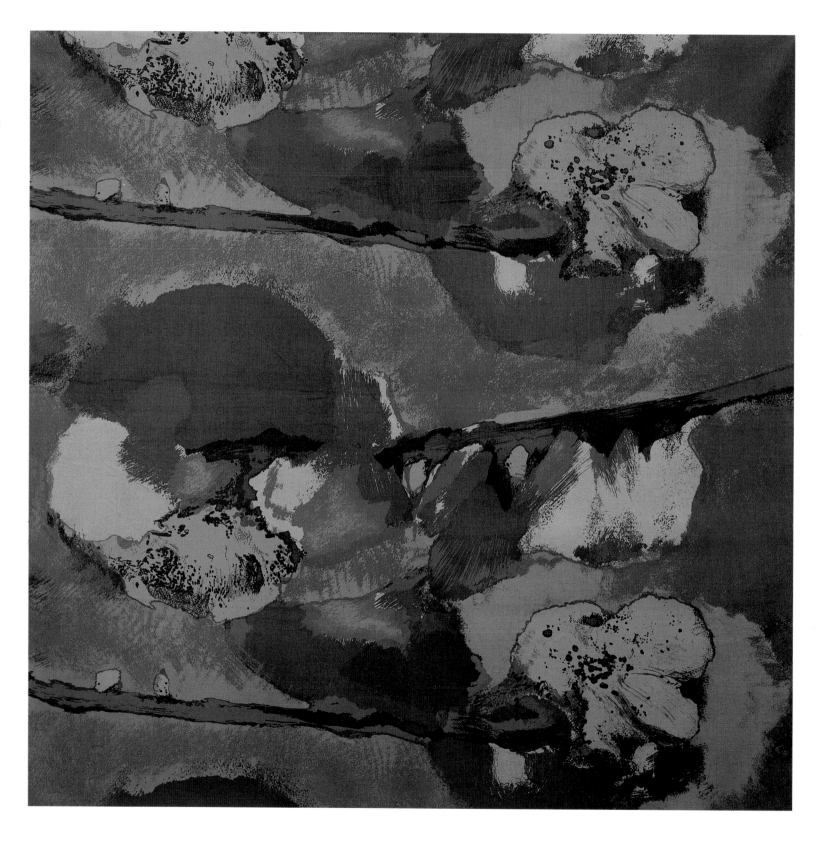

65. *Wild Bloom*, screen-printed cotton satin, designed by Doreen Dyall for Hull Traders Ltd, *c.* 1965. T 162-1989.

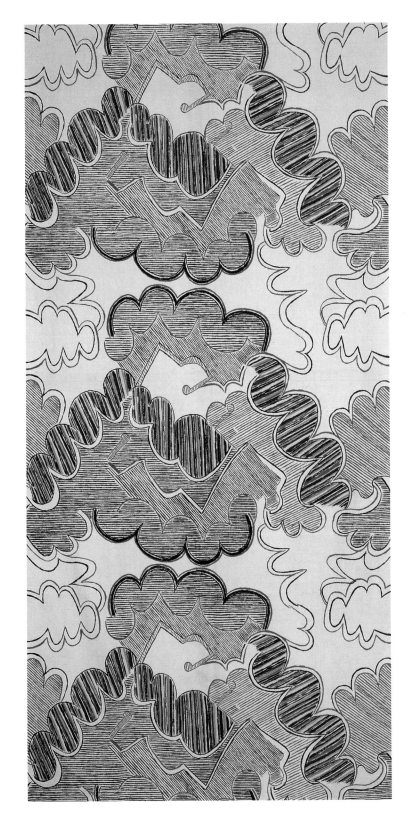

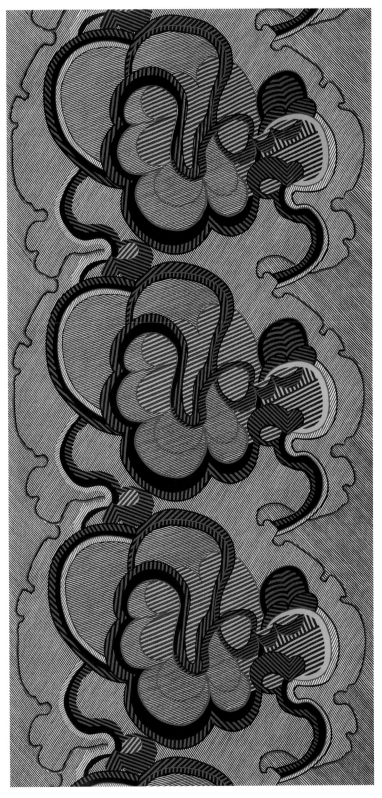

66. *Five*, screen-printed linen and cotton, designed by Shirley Craven for Hull Traders Ltd, 1966. Circ 760-1967.

67. *Simple Solar*, screen-printed cotton satin, designed by Shirley Craven for Hull Traders Ltd, 1968. Circ 791-1968.

68. *Oeta*, jacquard woven ramie, wool and cotton, designed by Victor Vasarely for
Edinburgh Weavers Ltd, 1962. Circ 694-1966.

69. *Recurrence*, screen-printed cotton crêpe, designed by Barbara Brown for Heal Fabrics Ltd, 1962. Circ 657-1962.

70. *Expansion*, screen-printed cotton satin, designed by Barbara Brown for Heal Fabrics Ltd, 1966.Circ 269-1967.

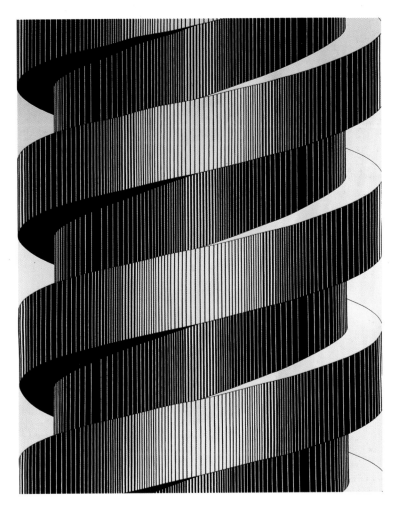

71. *Impact*, screen-printed cotton, designed by Evelyn Brooks for Heal Fabrics Ltd, 1965. Circ 250-1967.

72. *Spiral*, screen-printed cotton, designed by Barbara Brown for Heal Fabrics Ltd, 1969.Circ 784-1969.

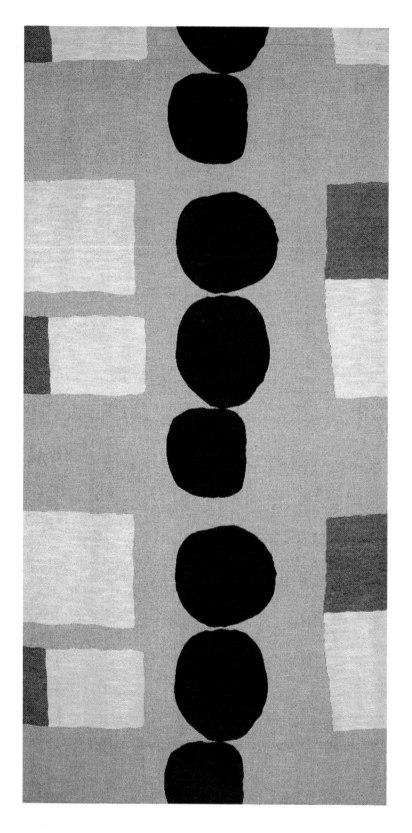

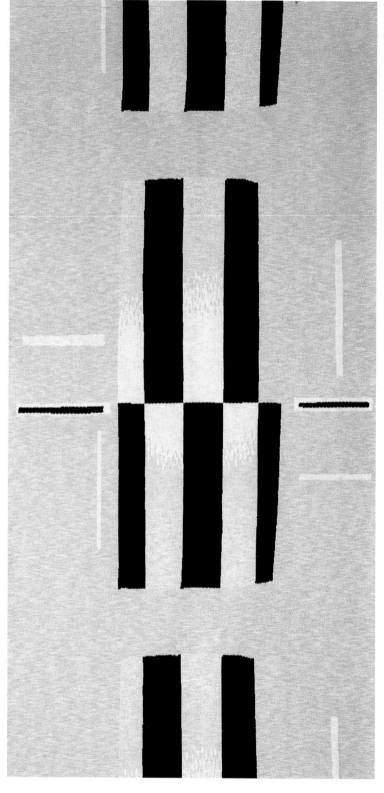

73. *Nearing Circles*, jacquard woven wool and linen, designed by William Scott for Edinburgh Weavers Ltd, 1962. Circ 324-1963.

74. *Megalith*, jacquard woven cotton and rayon, designed by Alan Reynolds for Edinburgh Weavers Ltd, 1964. Circ 20-1965.

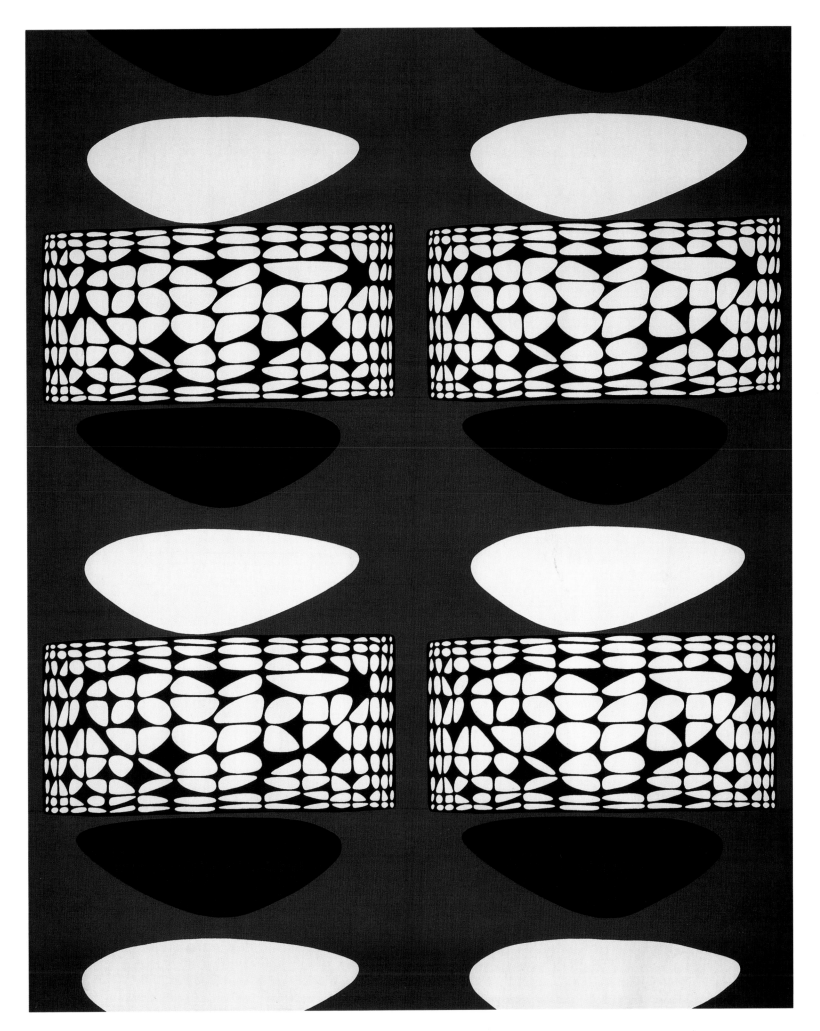

75. *Kernoo*, screen-printed cotton, designed by Victor Vasareley for
Edinburgh Weavers Ltd, 1962. Circ 327-1963.

76. *Chains*, woven tapestry, wool with a cotton warp, designed by Archie Brennan for the Edinburgh Tapestry Company Ltd, 1974–5. T 187-1979.

77. *Daisy Chain*, design for printed cotton, by Pat Albeck, 1964. E 851-1979.

80

79. *Prince of Quince*, screen-printed linen union, designed by Juliet Glyn-Smith for
Conran Fabrics Ltd, 1965. Circ 71-1967.

81. *Quarto*, screen-printed cotton satin, designed by Margaret Cannon for
Hull Traders Ltd, 1969. T 128-1989.

82. *Indian Summer*, screen-printed cotton crêpe, designed by Jyoti Bhomik for
Heal Fabrics Ltd, 1966. Circ 261-1967.

83. *Petrus*, screen-printed cotton crêpe, designed by Peter Hall for
Heal Fabrics Ltd, 1967.Circ 28-1968.

84

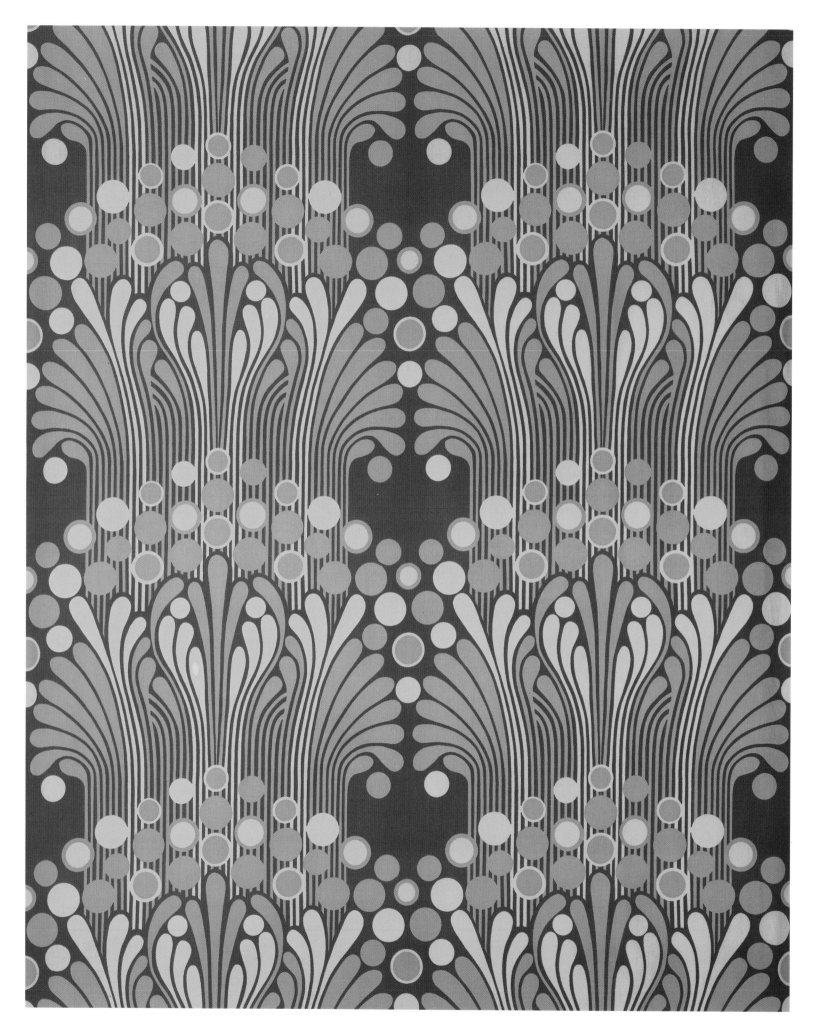

84. *Tivoli*, screen-printed cotton, designed by Peter Hall for
Heal Fabrics Ltd, 1967. Circ 27-1968.

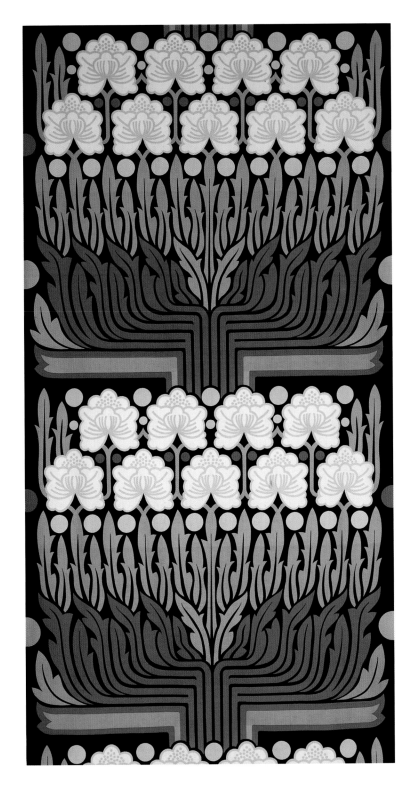

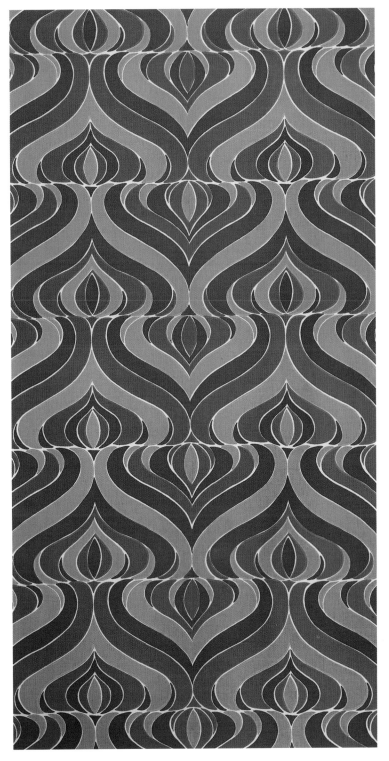

85. *Rosamund*, screen-printed cotton, designed by Peter Hall for Heal Fabrics Ltd, 1975. T 726-1997.

86. *Minar*, screen-printed cotton, designed by Shelagh Wakely for Fedelis Furnishing Fabrics Ltd, 1966. Circ 5-1967.

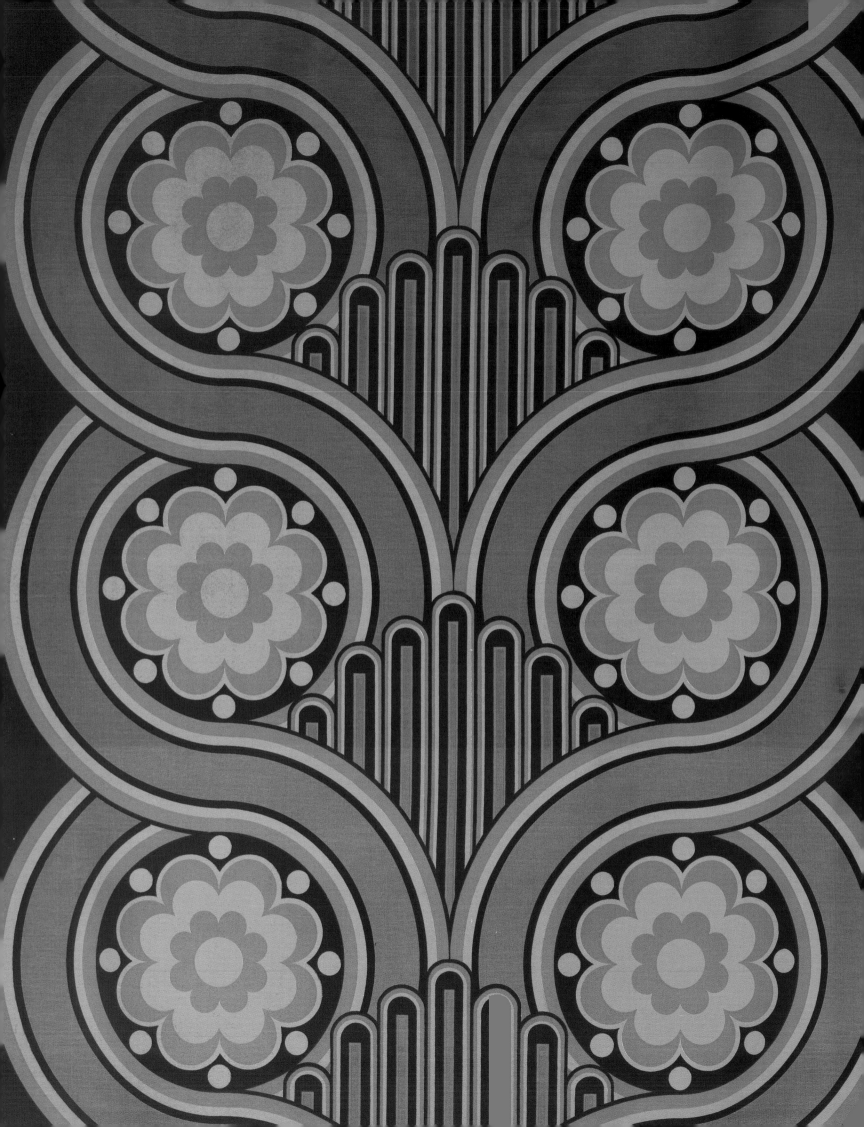

87. *Volution*, screen-printed cotton satin, designed by Peter Hall for Heal Fabrics Ltd, 1969. Circ 40-1969.

88. *Archway*, screen-printed cotton, designed by Eddie Squires for Warner & Sons Ltd, 1968. Circ 44-1969.

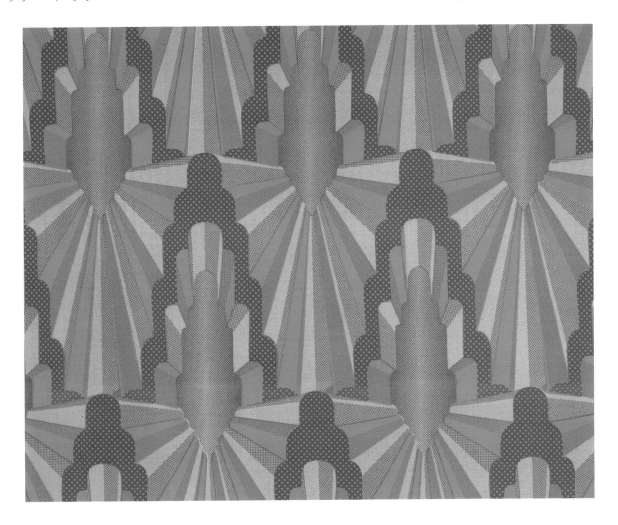

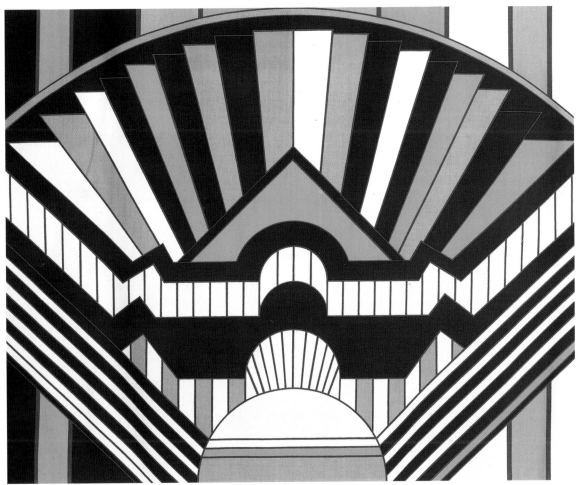

89. *Arcade*, screen-printed cotton, designed by Janet Taylor for Heal Fabrics Ltd, 1969. Circ 30-1969.

88

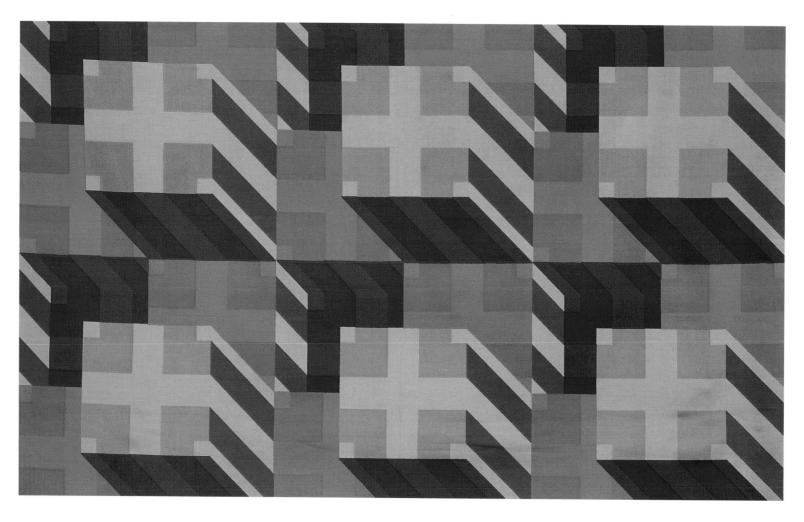

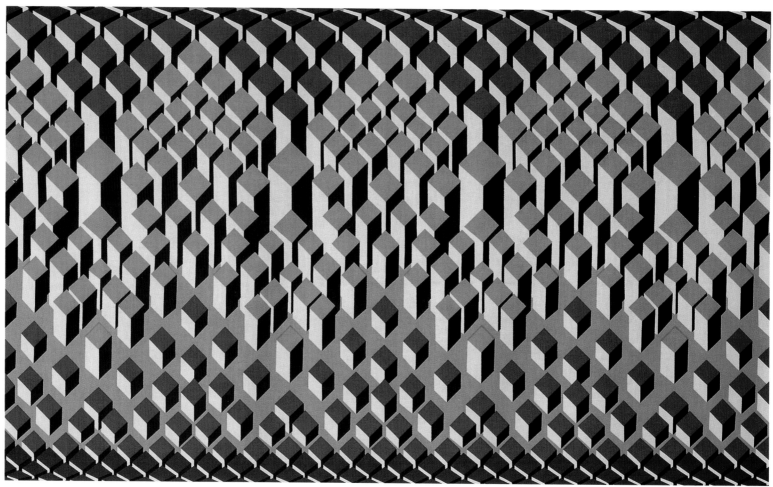

91. *Metropolis*, screen-printed cotton, designed by David Bartle for Textra Furnishing Fabrics Ltd, 1973. Circ 355-1973.

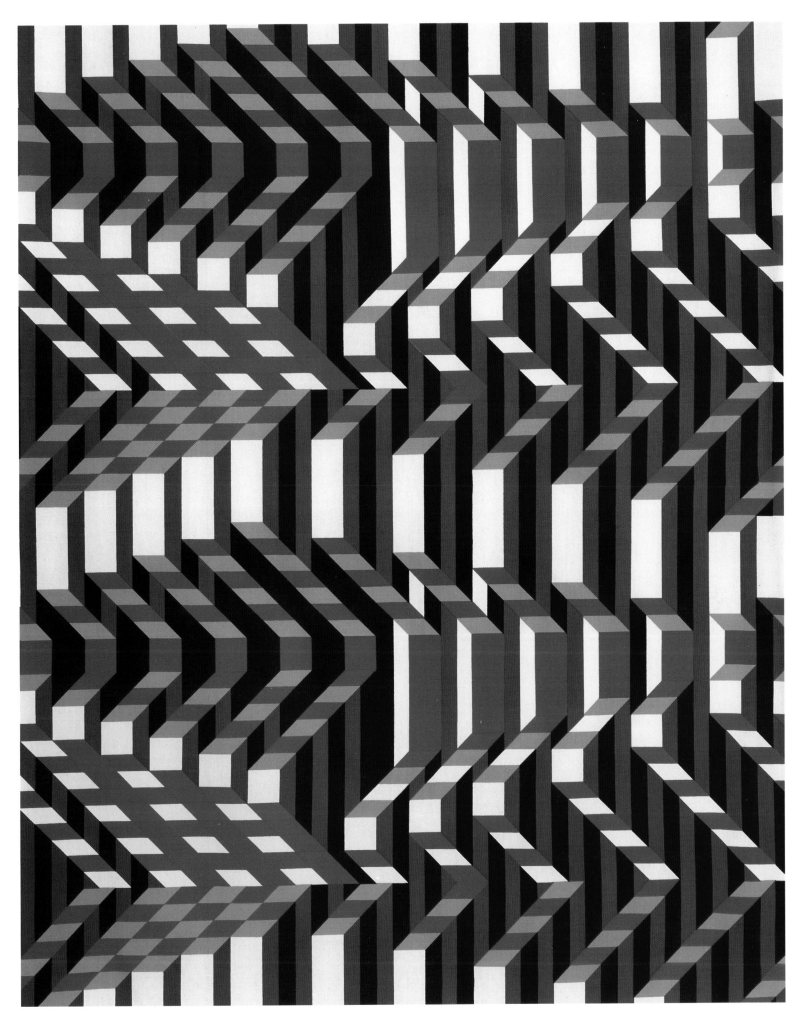

92. *Extension*, screen-printed cotton, designed by Haydon Williams for Heal Fabrics Ltd, 1967. Circ 30-1968.

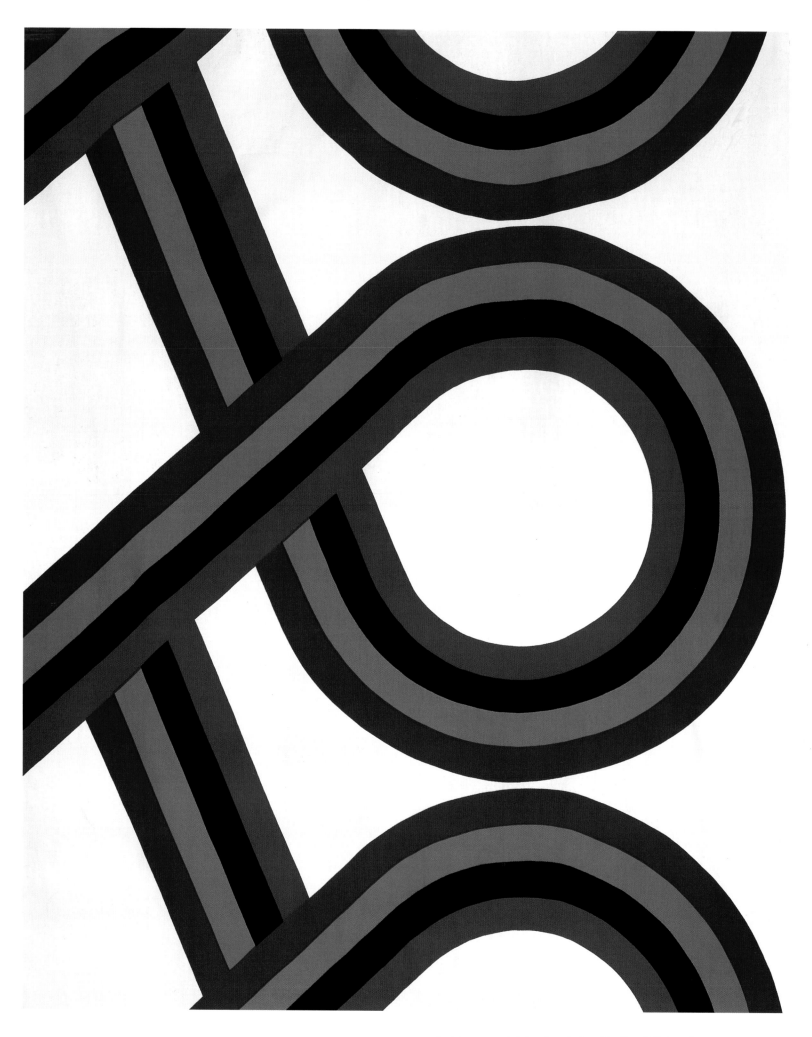

93. *Lariat*, screen-printed cotton, designed by Hamdi El Attar for Heal Fabrics Ltd, 1969. Circ 36-1969.

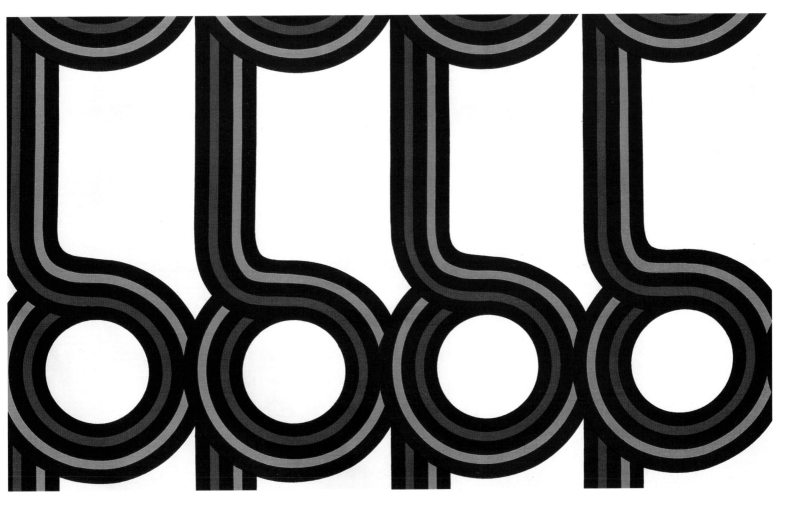

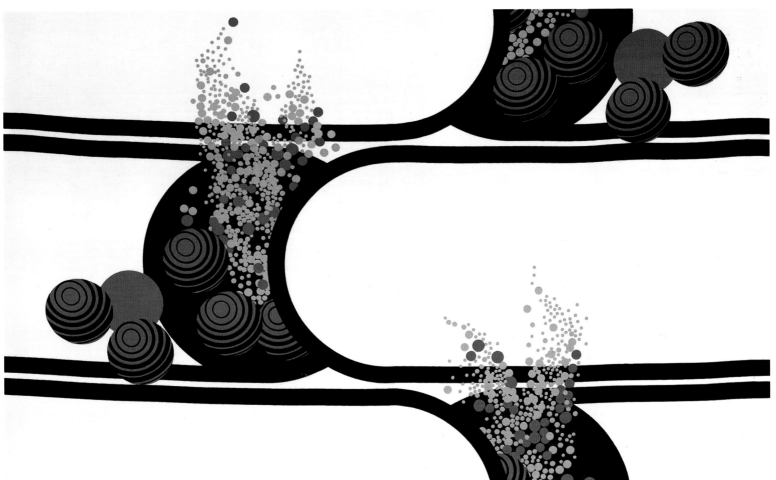

95. *Ikebana*, screen-printed cotton satin, designed by Barbara Brown for
Heal Fabrics Ltd, 1970. Circ 141-1976.

92

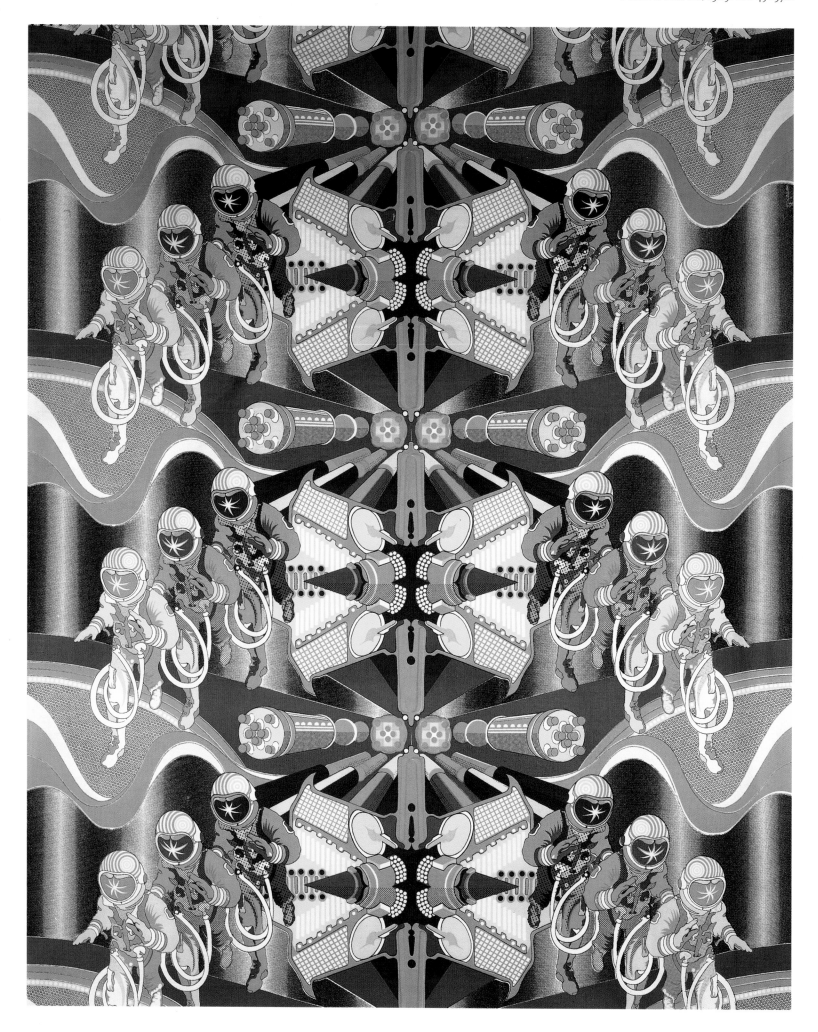

96. *Space Walk*, screen-printed cotton, designed by Sue Palmer for
Warner & Sons Ltd, 1969. Circ 44-1970.

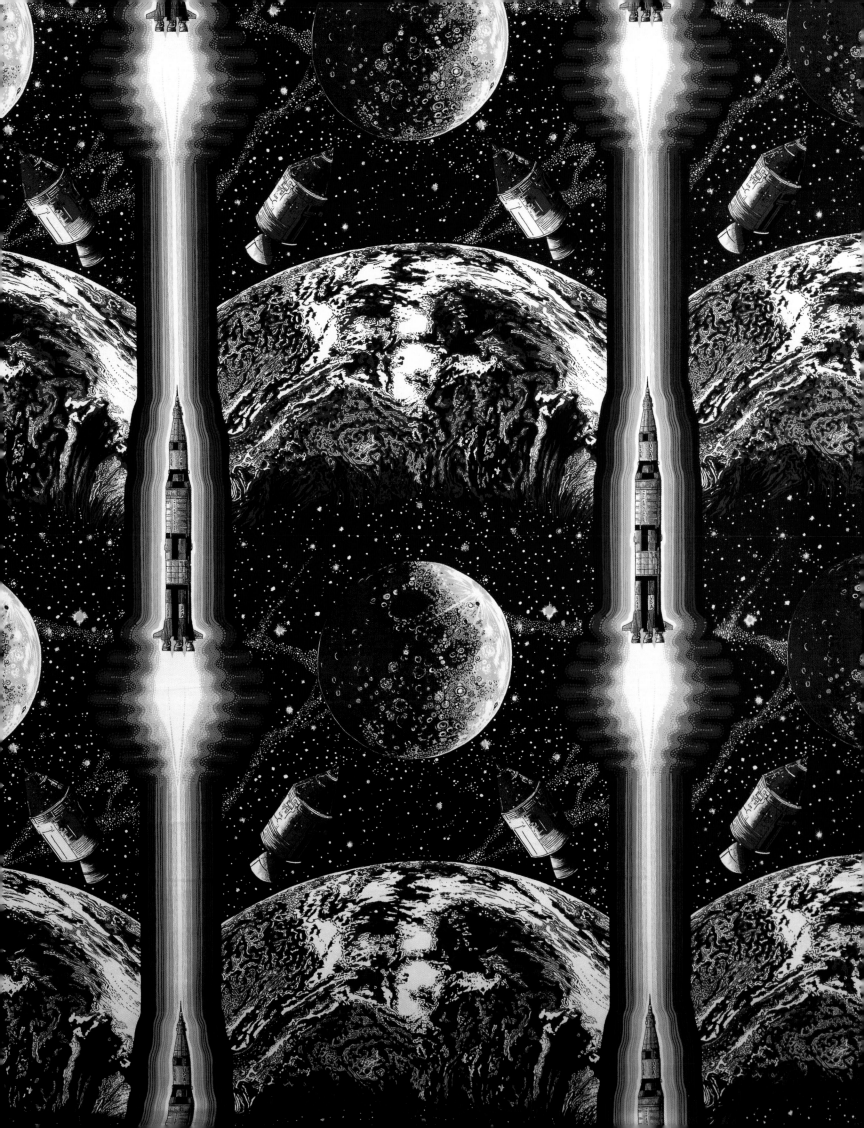

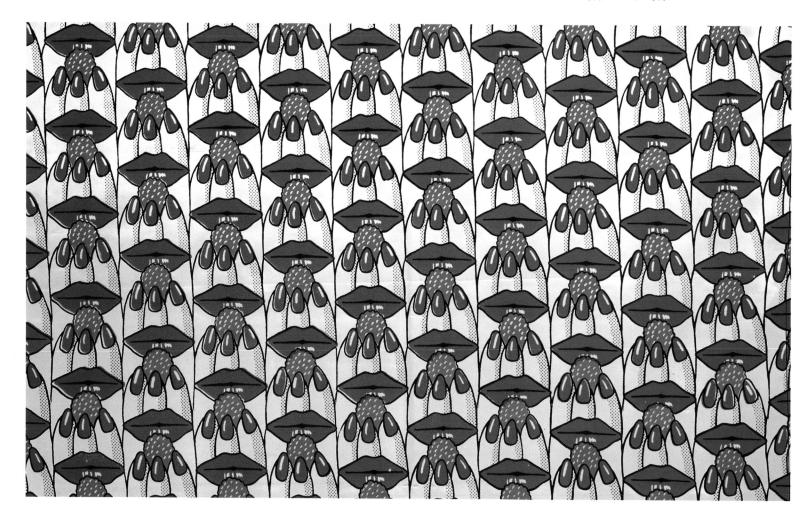

94

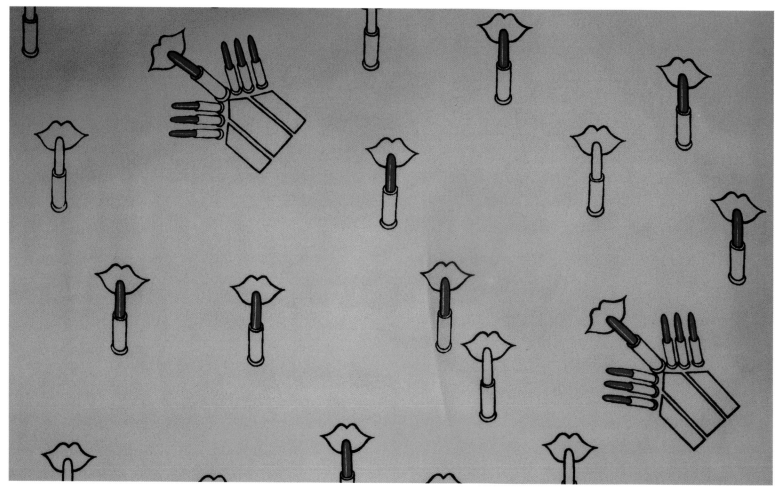

99. *Lipstick*, screen-printed silk crêpe, designed by Zandra Rhodes, 1968. Circ 266-1974.

100. *Cakes*, screen-printed synthetic ground with satin finish, designed by Jane Wealleans for OK Textiles Ltd, 1973. Circ 171- 1973.

101. *Soup Can*, screen-printed silk, designed by Lloyd Johnson for Patrick Lloyd Ltd, 1973. Circ 302-1973.

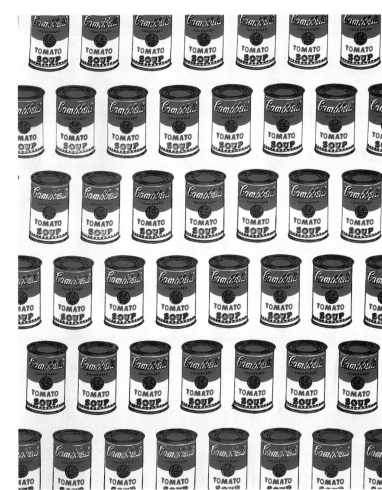

102. *Salad Days*, screen-printed cotton, designed by Kay Politowicz for Textra Fabrics Ltd, 1973. Circ 350-1973.

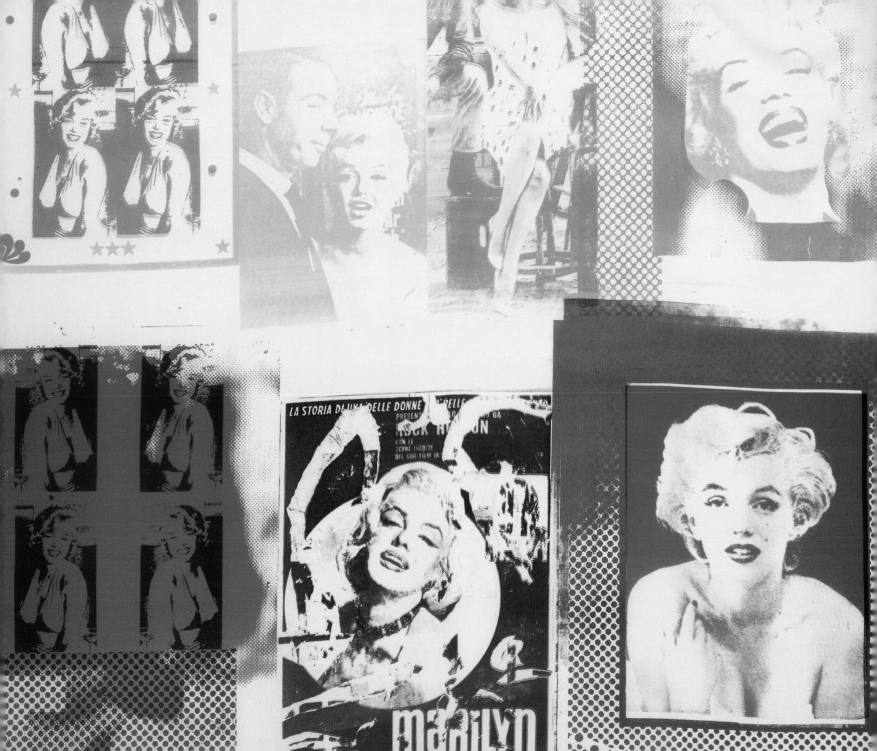

103. *Marilyn*, screen-printed synthetic ground with crêpe finish, designed by Christopher Snow and produced by Slick Brands (Clothing) Ltd, 1974. Circ 450-1974.

104. *Legs*, screen-printed synthetic ground with satin finish, designed by Jane Wealleans for OK Textiles Ltd, 1973. Circ 169-1973.

105. *Fred*, screen-printed silk, designed by Lloyd Johnson and produced by Patrick Lloyd, 1973. Circ 303-1973.

106. *Button Flower*, screen-printed silk chiffon, designed by
Zandra Rhodes, 1971. Circ 263-1974.

107. *Camelia*, screen-printed cotton, designed by Mary Oliver for
Heal Fabrics Ltd, 1975. T 752-1997.

100

108. *Graphic Two*, screen-printed cotton, designed by the Ryman-Conran Studio for Conran Fabrics Ltd, London, 1970. Circ 93-1971.

110. *Clandon*, roller-printed cotton, designed by Susan Collier and Sarah Campbell for Liberty of London Prints Ltd, 1977. T 43-1978.

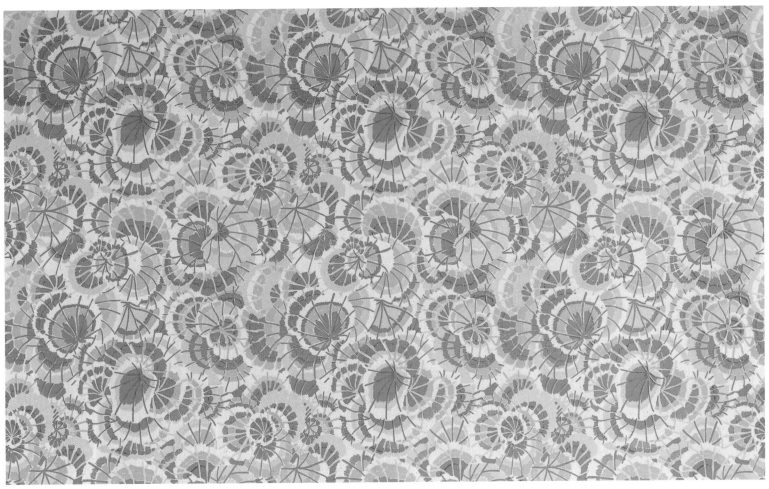

112. *Geranium*, screen-printed cotton, designed and produced by Designers Guild Ltd, 1976. T 69-1978.

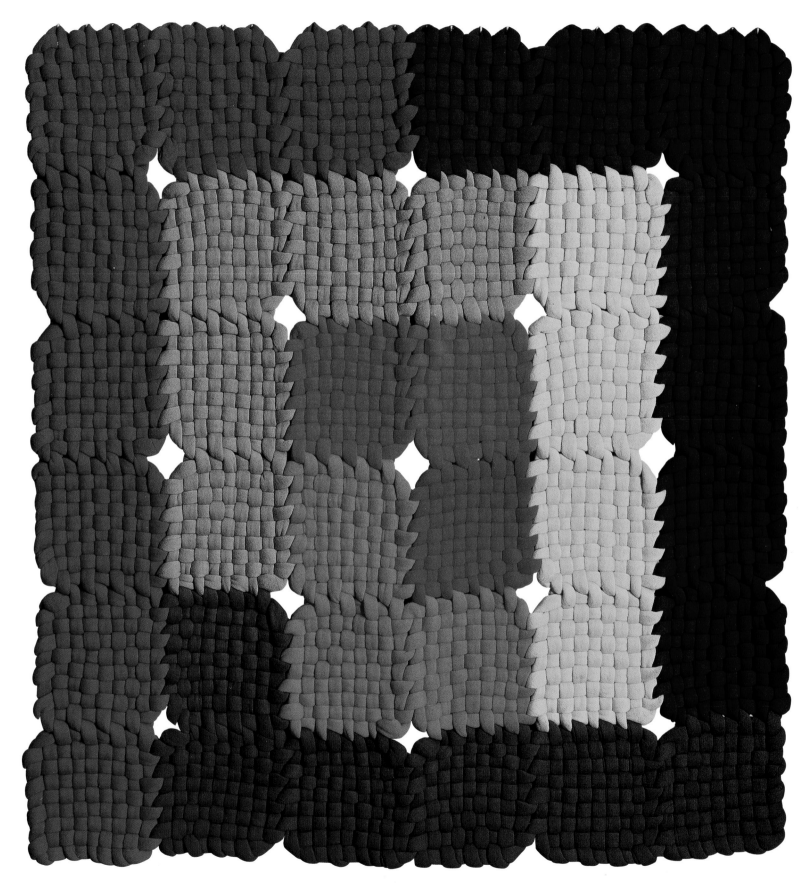

113. *Square Spectrum Spiral*, interlaced woollen knitted tubes, by Ann Sutton, 1973. T 76-1982.

114. Dyed and woven calico and mercerized cotton, by John Hinchcliffe, 1978.
T 161-1978.

Côte D'Azure, screen-printed cotton, designed by Susan Collier and Sarah Campbell for Fischbacher Ltd, 1983. T 187-1984.

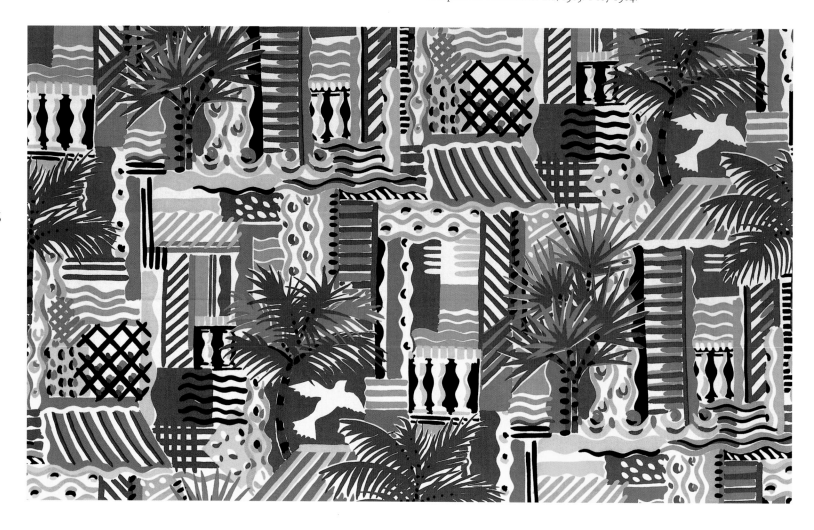

106

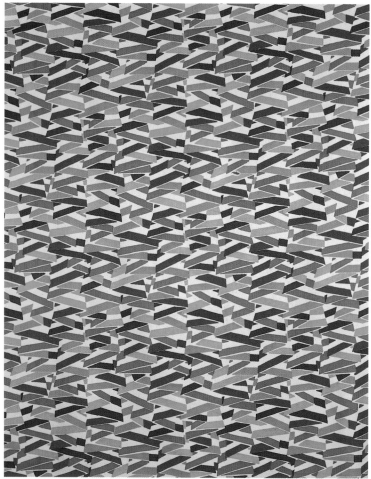

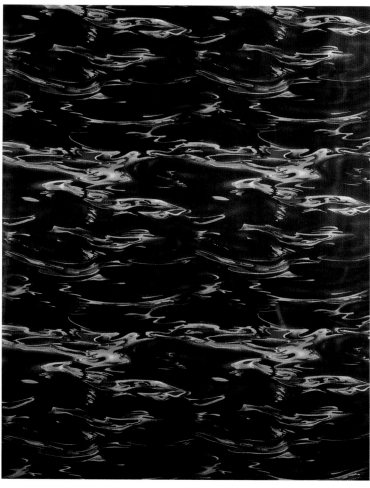

116. *Havana*, screen-printed cotton, designed by Susan Collier and Sarah Campbell for Fischbacher Ltd, 1983. T 185-1984.

117. *Aquarelle*, screen-printed glazed cotton, designed by Sue Palmer for Warner & Sons Ltd, 1985. T 145-1987.

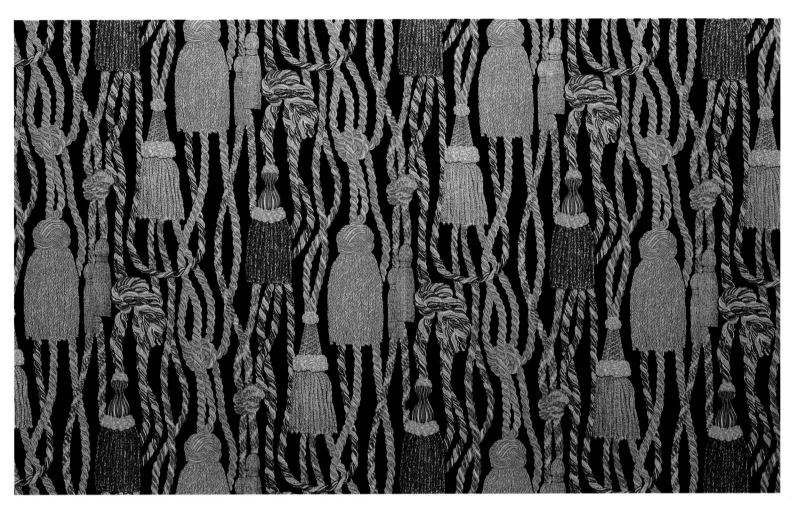

118. *London Tassels*, screen-printed glazed cotton, designed by Mandy Martin for Warner Fabrics plc, 1987. T 42-1990.

107

119. *Panache*, screen-printed glazed cotton, designed by Anne White for Warner & Sons Ltd, 1985. T 148-1987.

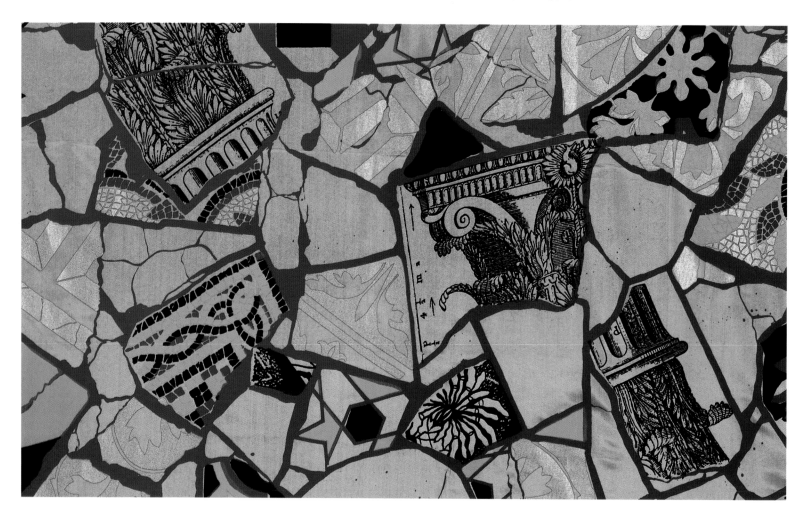

108

121. *Fallen Angel*, screen-printed cotton satin, designed and produced by Timney Fowler Ltd, 1986. T 201-1989.

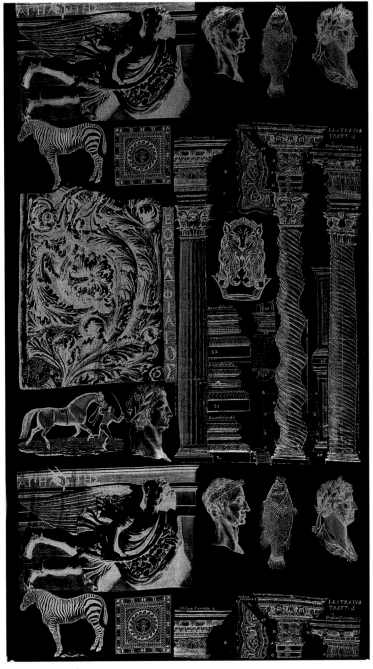

122. *Columns*, screen-printed cotton satin, designed by
Timney Fowler Ltd, 1983. T 207-1989.

123. *Composite* or *Collage*, discharge-printed cotton velvet, designed by
Timney Fowler Ltd, 1987. T 205-1989.

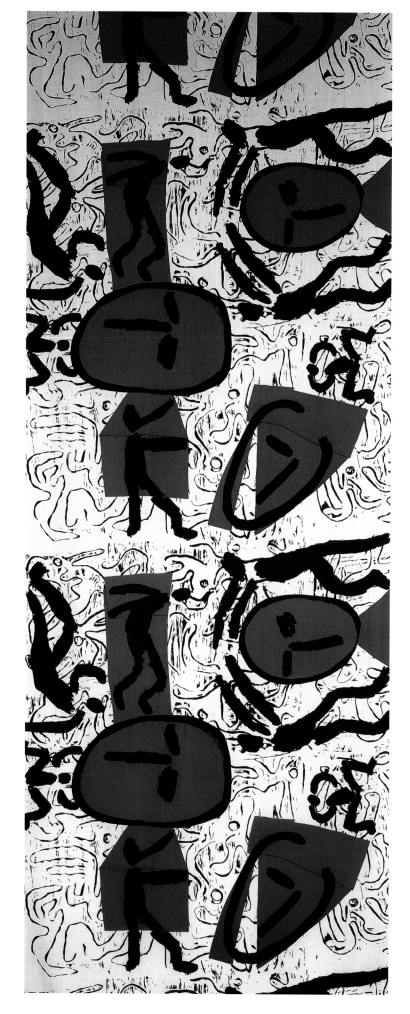

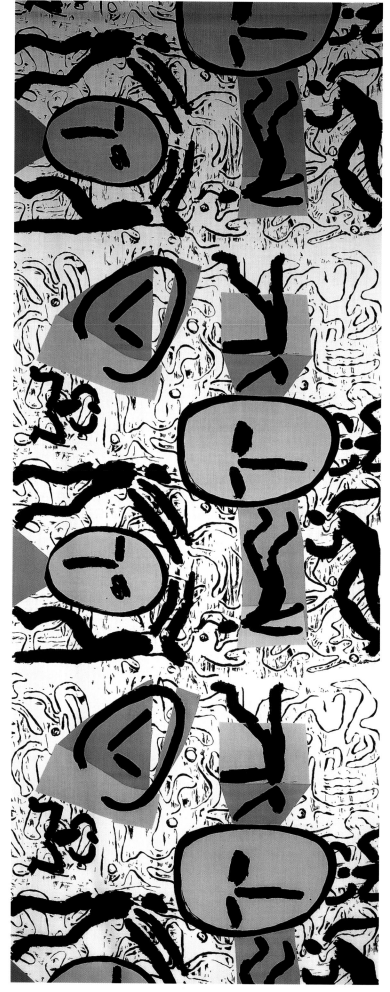

124. Screen-printed wool, designed and printed by The Cloth Ltd, 1985. T 200-1987.

125. Screen-printed wool, designed and printed by The Cloth Ltd, 1985. T 199-1987.

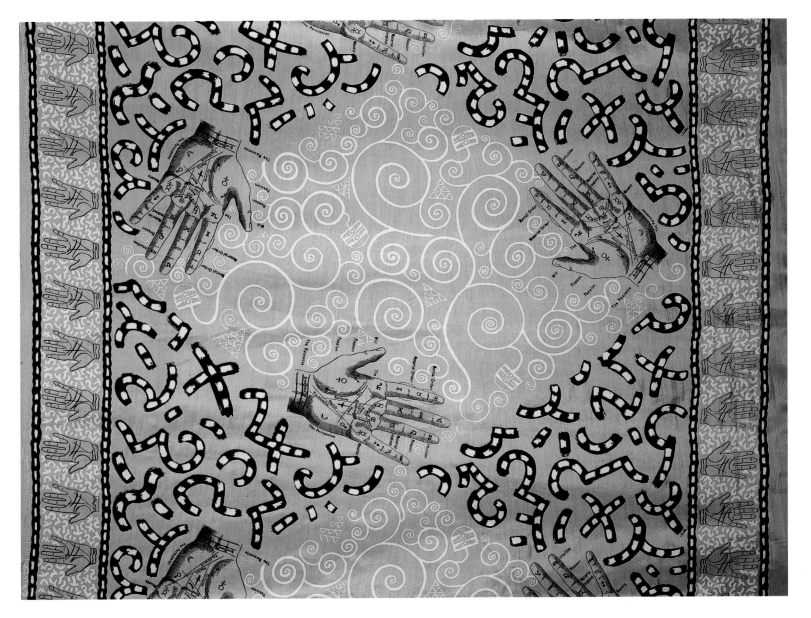

126. *Hands*, screen-printed and discharge-dyed silk, designed by
Helen Littman for English Eccentrics, 1986. T 297-1988.

127. *Water*, screen-printed glazed cotton, designed by Howard Hodgkin for
Warner & Sons Ltd, 1983. T 233A-1984.

129. Ikat silk, by Mary Restieaux, 1980. T 432-1980.

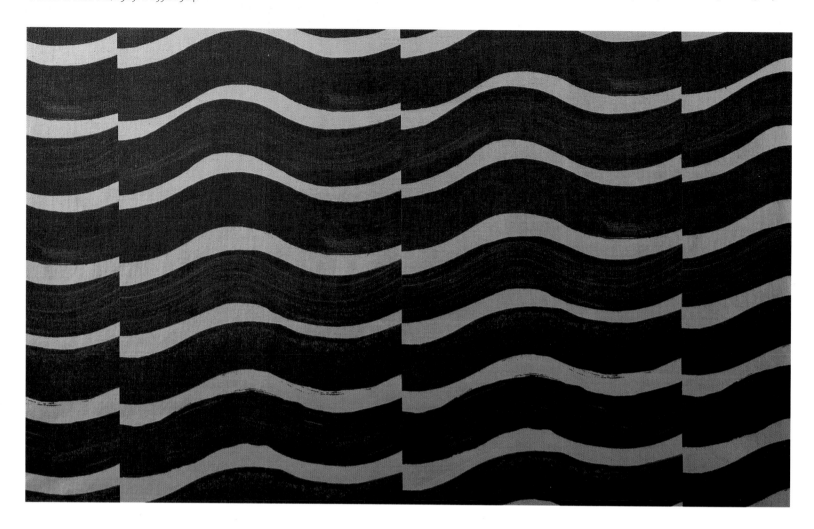

112

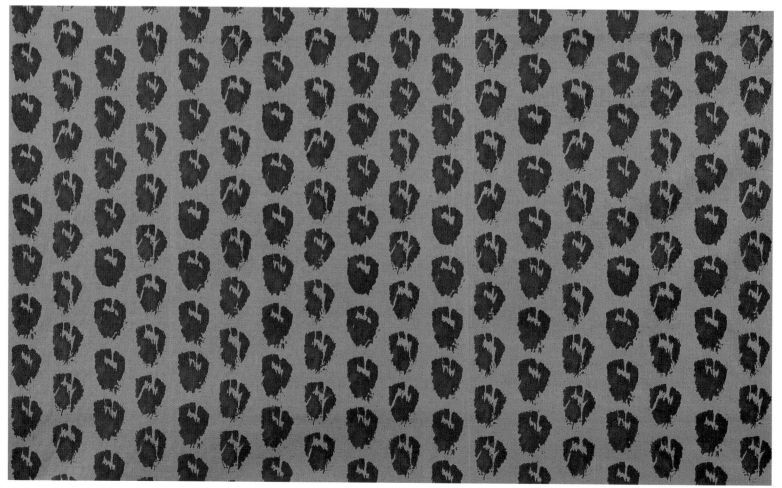

128. *Autograph*, screen-printed glazed cotton, designed by Howard Hodgkin for
Warner & Sons Ltd, 1983. T 232-1984.

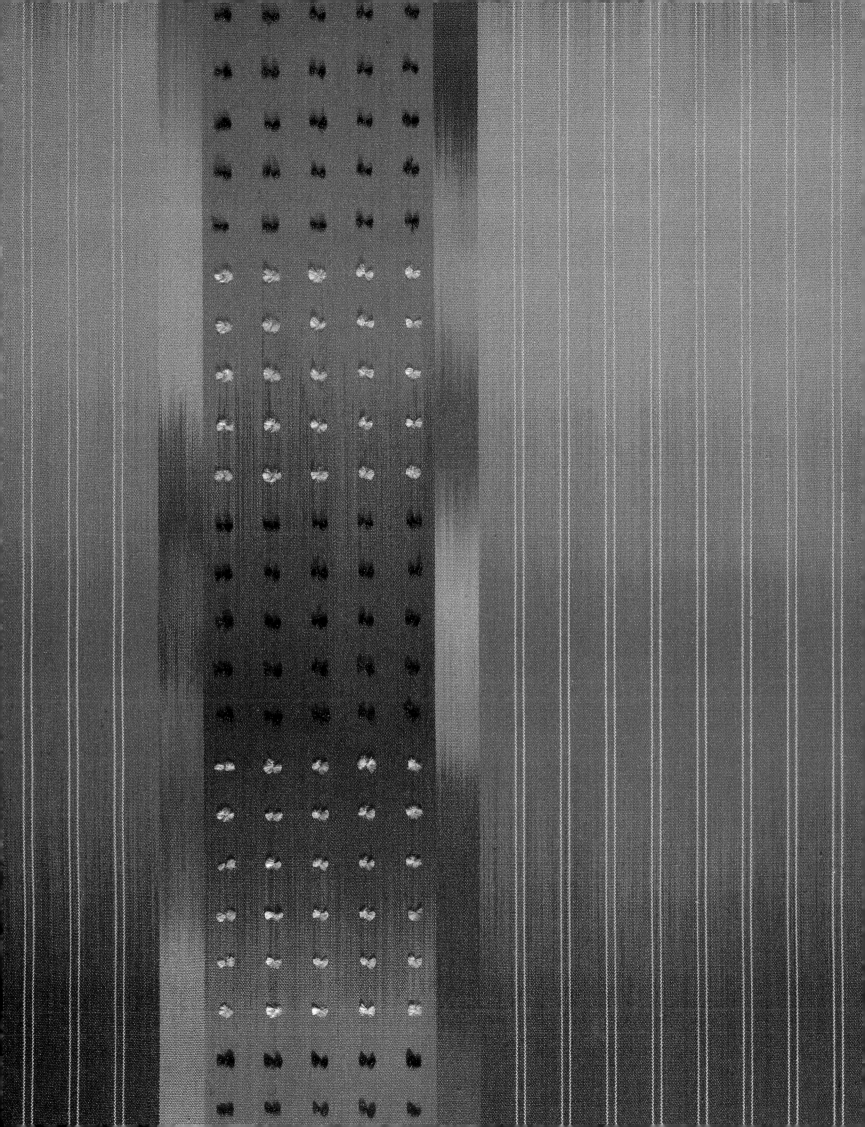

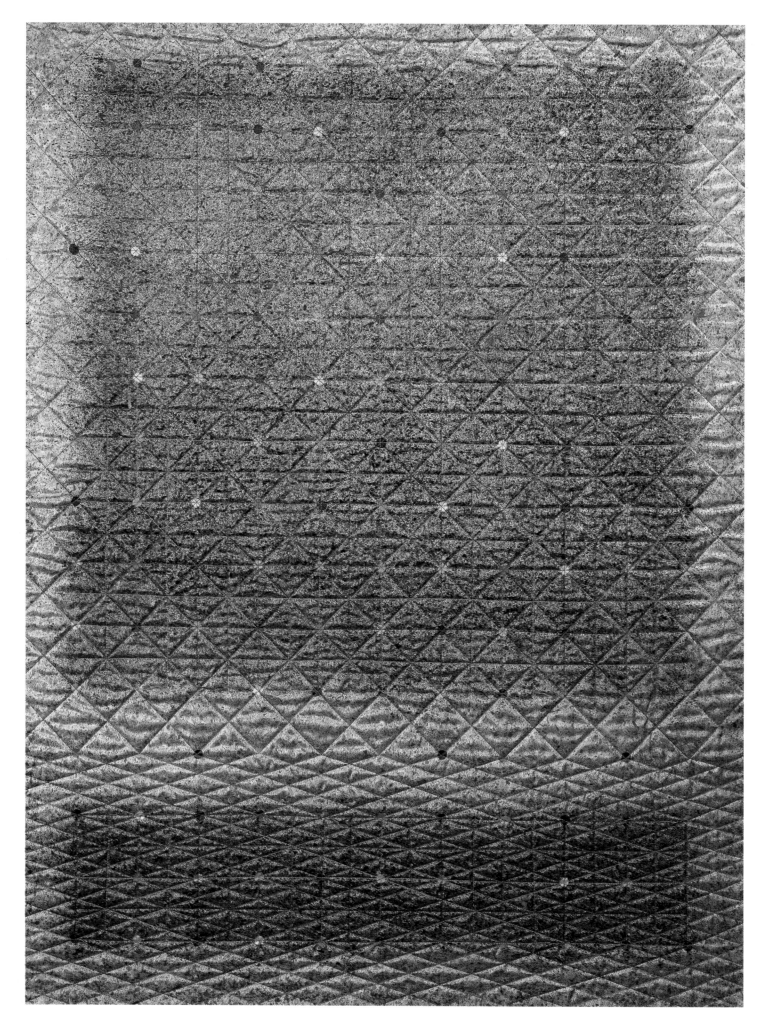

130. Quilted and spray-dyed acetate satin, by Diana Harrison,
1985. T 151-1985.

131. *Release*, batik-dyed cotton, by Noel Dyrenforth, 1981. T 89-1989.

132. Painted wool, by Sian Tucker, 1986. T 133-1986.

133. Screen-printed and dyed silk, by Victoria Richards, 1989. T 258-1989.

134. Screen-printed and painted silk, by Neil Bottle, 1990. T 272-1991.

135. *TOW 873*, painted spun silk, by Sally Greaves-Lord, 1988. T 122-1988

136. *Grand Acanthus*, screen-printed cotton, designed by Paul Simmons for Warner Fabrics plc, 1993. T 166-1993.

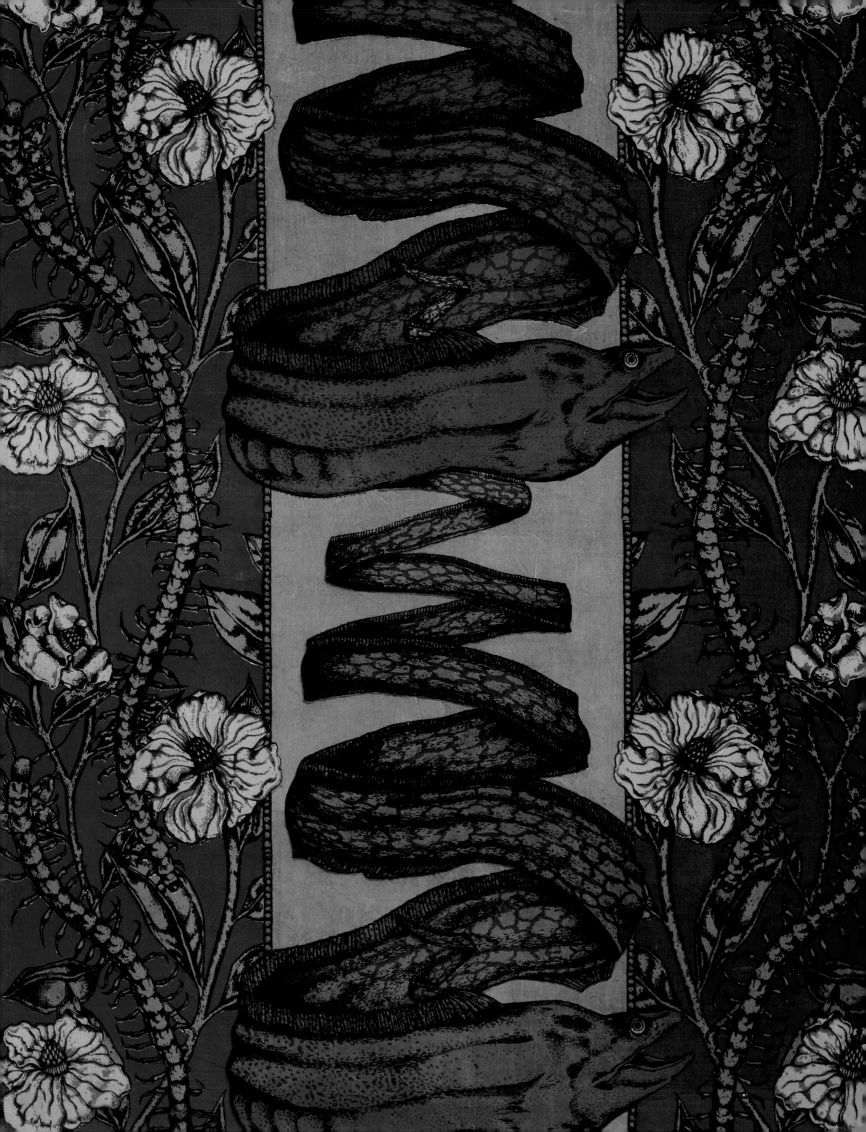

137. *Large Eel*, screen-printed cotton velvet, designed by Paul Simmons for Timorous Beasties, 1992. T 422-1992.

138. *May Tree*, screen-printed cotton, designed by Michael Heindorff for Designers Guild Ltd, 1992. T 425:1-1992.

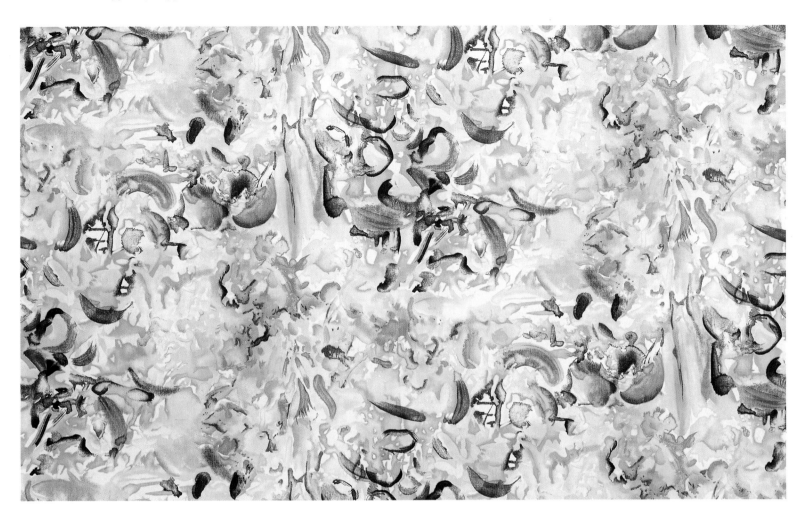

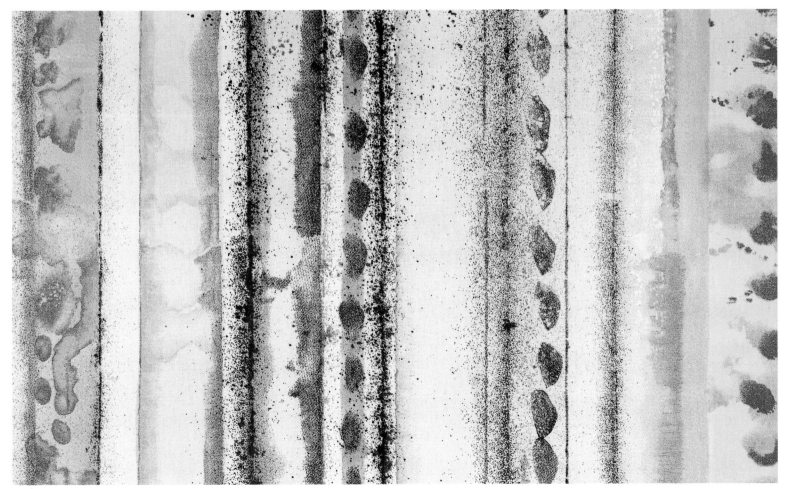

139. *Tracer*, screen-printed cotton, designed by Michael Heindorff for Designers Guild Ltd, 1992. T 428:3-1992.

122

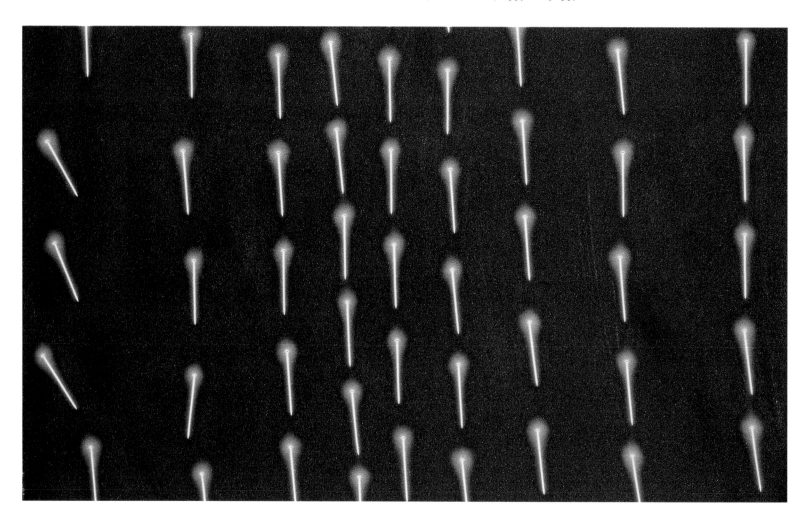

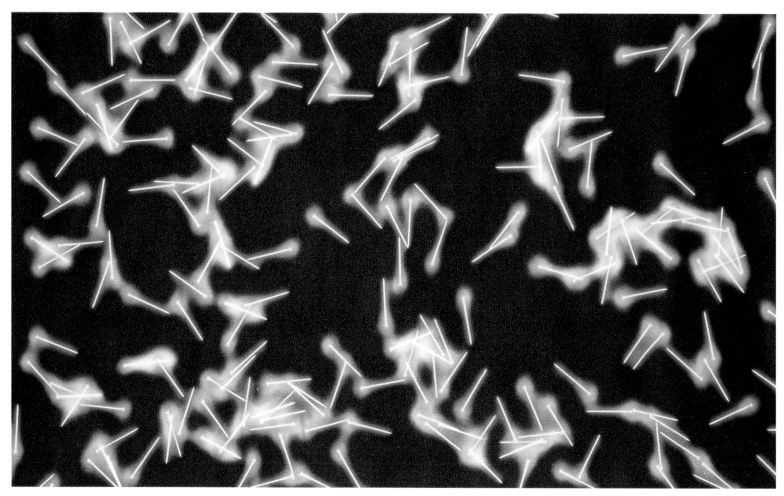

141. *Scattered Pins*, heat-photogram printed microfibres,
by Rebecca Earley, 1995. T 126-1997.

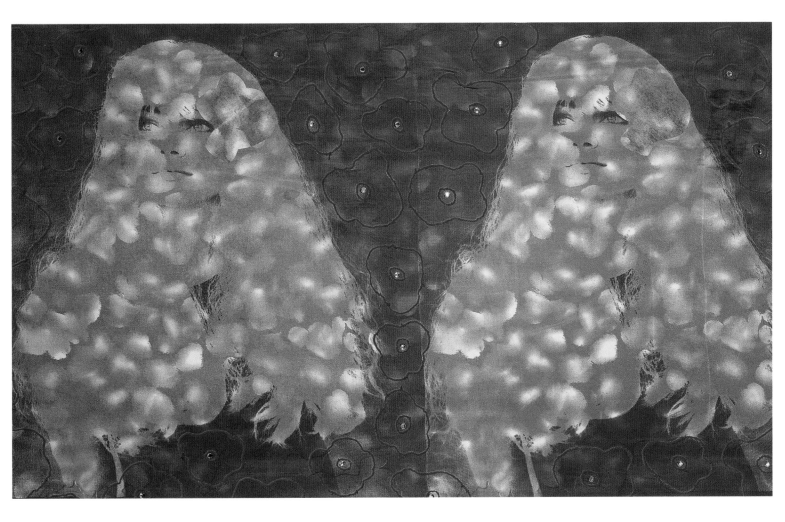

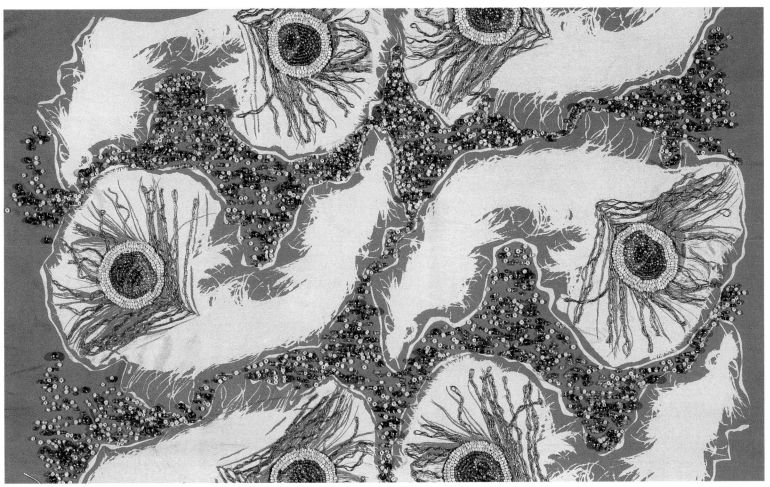

143. Screen-printed and decorated crêpe-de-chine, designed by Luiven Rivas-Sanchez, 1990. T 474-1992.

Edelweiss Smocking, screen-printed and heat-treated silk/viscose velvet, by Nigel Atkinson, 1990. T 530-1994.

145. *Sea Anemone*, screen-printed and heat-treated silk, by Nigel Atkinson, 1989. T 527-1994.

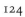

124

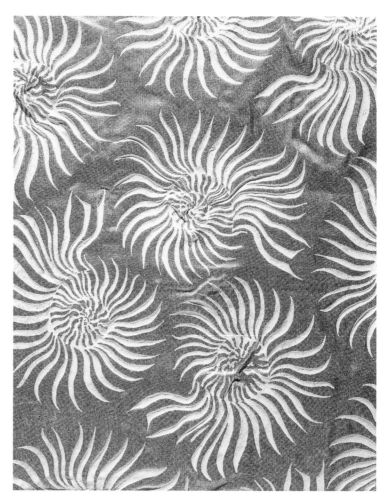

146. *Tigermoon*, silk/viscose devoré, designed by Neisha Crosland, 1996. T 495-1997.

147. *Checkered Flower*, screen-printed and heat-treated silk organza woven with metal threads, designed by Neisha Crosland, 1997. T 493-1997.

148. *Shrine*, painted spun silk, by Carole Waller,
1996. T 121-1997.

149. Silk/viscose velvet devoré, by Sharon Ting, 1997. T 168-1997.

150. *Peeling Paint*, wool devoré, by Gilian Little, 1996. T 147-1997.

Further Reading

The following titles are recommended in addition to those cited in the section 'Notes on Firms, Designers and Makers'. (Books in the first section were published in London unless otherwise stated.)

ADBURGHAM, A. *Liberty's: A Biography of a Shop*, George Allen & Unwin Ltd, 1975

ALBERS, ANNI. *Anni Albers: On Weaving*, Wesleyan University Press, Middletown, Connecticut, USA, 1965

BANHAM, M. AND HILLIER, B. *A Tonic To The Nation: The Festival of Britain 1951*, Thames & Hudson, 1976

BRADDOCK, S. AND O'MAHONY M. *Techno Textiles: Revolutionary Fabrics for Fashion and Design*, Thames & Hudson, 1998

CAWTHORNE, N. *Sixties Source Book: A Visual Reference to the Style of a New Generation*, Quarto Publishing plc, 1989

COLCHESTER, C. *The New Textiles: Trends and Traditions*, Thames and Hudson, 1991

COULSON, A. *A Bibliography of Design in Britain 1851–1970*, Design Council, 1979

DORMER P. (ed.) *The Culture of Craft*, Manchester University Press, Manchester, 1997

FARR, M. *Design in British Industry: A Mid-Century Survey*, Cambridge University Press, Cambridge, 1955

GOODDEN, S. *A History of Heal's*, Heal & Son Ltd, 1984

HAYES MARSHALL, H. G. *British Textile Designers Today*, F. Lewis, Leigh-on-Sea, 1939

HINCHCLIFFE, F. *Fifties Furnishing Fabrics*, Webb & Bower, Exeter, 1989

HUYGEN, F. *British Design: Image & Identity*, Thames & Hudson in association with Boymans-Van Beuningen Museum, 1989

KOUMIS, M. (ed.) *Art Textiles of the World: Great Britain*, Telos Art Publishing, Winchester, 1996

LEWIS, F. (ed.) *British Designers and their Work*, F. Lewis, Leigh-on-Sea, 1941

LOVAT FRASER, G. *Textiles by Britain*, Allen & Unwin, 1948

MACCARTHY, F. *British Design since 1880*, Lund Humphries, 1982

MCDERMOTT, C. *Essential Design*, Bloomsbury Publishing plc, 1992

MCDERMOTT, C. (ed.) *English Eccentrics: The Designs of Helen Littman*, Phaidon Press Ltd, 1992

MCINTYRE, J. E. AND DANIELS, P. N. (eds) *Textile Terms and Definitions*, 10th edn, Textile Institute, Manchester, 1995

MAIRET, E. *Handweaving Today*, Faber and Faber, 1939

MENDES, V. *Novelty Fabrics*, Webb & Bower, Exeter, 1988

MENDES, V. *The Victoria and Albert Museum's Textile Collection: British Textiles from 1900 to 1937*, V&A, 1992

MORTON, J.W.F. *Three Generations in a Family Textile Firm*, Routledge & Kegan Paul, 1971

PEVSNER, N. *An Enquiry into Industrial Art in England*, Cambridge University Press, Cambridge, 1937

POWERS, A. *Modern Block Printed Textiles*, Walker Books, 1992

SCHOESER, M. *International Textile Design*, Laurence King Publishing, 1995

SCHOESER, M. *Fabrics and Wallpapers: Twentieth Century Design*, Unwin Hyman, 1986

SCHOESER, M. AND RUFEY, C. *English and American Textiles from 1790 to the Present*, Thames & Hudson, 1989

SPARKE, P. (ed.) *Did Britiain Make It? British Design in Context 1946–86*, Design Council, 1986

STEWART, R. *Design and British Industry*, John Murray Publishers Ltd, 1987

STOREY, J. *Textile Printing*, Thames and Hudson, 1974

STOREY, J. *Dyes and Fabrics*, Thames and Hudson, 1978

Exhibition Related Publications

Works listed range from leaflets and handlists to catalogues and books. In the case of touring exhibitions, only the first venue is given.

Austerity to Affluence: British Art and Design 1945–1962, Fine Art Society, London: Merrell Holberton Publications, 1997

Berriman, H. *Cryséde: The Unique Textile Designs of Alec Walker*, Royal Cornwall Museum, Truro: Royal Institution of Cornwall, 1993

Braddock, S. and O'Mahony, M. (eds) *Textiles and New Technology: 2010*, Crafts Council Gallery, London: Artemis Ltd, 1994

Brown/Craven/Dodd: 3 Textile Designers, Whitworth Art Gallery, Manchester: Richmond Press Ltd, 1965

128 Bury, H. *A Choice of Design 1850–1980: Fabrics by Warner &
Sons*, Warner & Sons Ltd, Braintree, 1981

*Catalogue of an Exhibition of English Chintz: Two Centuries of
Changing Taste*, Victoria and Albert Museum, London:
HMSO, 1955

A Century of Warner Fabrics 1870 to 1970, Victoria and Albert
Museum, London, 1973

Coatts, M. *A Weaver's Life: Ethel Mairet 1872–1952*, Crafts Study
Centre, Holburne Museum, Bath: Design Council, 1983

Collingwood/Coper, Victoria and Albert Museum, London:
HMSO, 1969

*Colour into Cloth: A Celebration of Britain's Finest Hand
Coloured Textiles 1900–1994*, Crafts Council Gallery,
London, 1994

The Craftsman's Art, Victoria and Albert Museum, London:
Crafts Advisory Committee, 1973

*Designs for British Dress and Furnishing Fabrics: 18th Century to
the Present*, Victoria and Albert Museum, London, 1986

Enid Marx: A Retrospective Exhibition, Camden Arts Centre,
London, 1979

The Fabric of Pop, Victoria and Albert Museum, London, 1974

Frayling, C. and Catterall, C. (ed.) *Design of the Times: One
Hundred Years of the Royal College of Art*, Royal College of
Art, London: Richard Dennis Publications/Royal College of
Art, n.d. [1996]

Greg, A. (ed.) *Primavera/Pioneering Craft and Design 1945–1995*,
Gateshead, Shipley Art Gallery: Tyne and Wear Museums,
1995

Hand Block Printed Textiles: Phyllis Barron and Dorothy Larcher,
Crafts Study Centre, Holburne Museum, Bath, 1978

Hann, M. A. and Thomson, G. M. *Tibor Reich (1916–1996)*,
Leeds University Gallery, 1997

Harris, J. *Lucienne Day: A Career in Design*, Whitworth Art
Gallery, Manchester, 1993

Harris, J., Hyde, S. and Smith, G. *1966 and All That*,
Whitworth Art Gallery, Manchester: Trefoil Books, 1986

Hiesinger, K. and Marcus, G. *Design Since 1945*, Philadelphia
Museum of Art, USA, 1983

International Biennials of Tapestry, Lausanne, from 1962

Jackson, L. *The New Look: Design in the Fifties*, Manchester City
Art Galleries: Thames & Hudson 1991

King, B. *Modern Art in Textile Design 1930–1980*, Whitworth
Art Gallery, Manchester, 1989

Lambert, S. *Paul Nash as Designer*, Victoria and Albert
Museum, London, 1975

Liberty's 1875–1975: An Exhibition to Mark the Firm's Centenary,
Victoria and Albert Museum, London, 1975

Master Weavers: Tapestry from the Dovecot Studios 1912–1980,
Scottish Arts Council, Edinburgh: Canongate Ltd, 1980

Mendes, V. and Hinchcliffe, F. *Ascher: Fabric, Art, Fashion*,
Victoria and Albert Museum, London, 1987

Modern Art in Textile Design, Whitworth Art Gallery,
Manchester, 1962

The Mortons: Three Generations of Textile Creation, Victoria and
Albert Museum, London, 1973

Painting into Textiles, Institute of Contemporary Arts, London,
1953 (for description see *The Ambassador*, November 1953,
pp. 71–90)

Peat, A. *David Whitehead Ltd: Artist Designed Textiles
1952–1969*, Oldham Art Gallery: Oldham Leisure Services,
1993

Schoeser, M. *Bold Impressions: Block Printing 1910–1950*,
Central St Martin's College of Art & Design, London, 1995

Schoeser, M. *Fifties Printed Textiles*, Warner & Sons Ltd,
Braintree, 1985

Schoeser, M. *Marianne Straub*, Design Council, London, 1984

The Scottish Tapestry Artists Group, Edinburgh (first exhibition
1978, second exhibition 1979, third exhibition 1980)

*Summary Catalogue of Textile Designs 1840–1985 in the Victoria
and Albert Museum* (book and colour microfiche), Emmett
Microform, Haslemere, 1986

Tadek Beutlich: Off the Loom!, Brighton and Hove Libraries and
Museums, 1997

Theophilus, L. and Wood, K. (ed.) *Peter Collingwood: Master
Weaver*, Minories Art Gallery, Colchester: Firstsite
Publication, 1998

Under Construction: Exploring Process in Contemporary Textiles,
Crafts Council Gallery, London, 1996

Utility Furniture and Fashion 1941–1951, Geffrye Museum,
London, 1974

Wall to Wall: Textiles for Interiors, Cornerhouse, Manchester,
1987

Weaving for Walls: Modern British Wall Hangings and Rugs,
Victoria and Albert Museum, London, 1965

Woods, C. *Sanderson 1860–1985*, Arthur Sanderson & Son Ltd,
London, 1985

Zandra Rhodes, Oriel Gallery, Cardiff, 1978